Sergei Eisenstein

Mise en jeu and Mise en geste

translated and
with an afterword
by Sergey Levchin

caboose
Montreal

PUBLISHED WITHOUT FINANCIAL ASSISTANCE, PUBLIC OR PRIVATE

Second edition.

© Copyright 2014, 2020 Timothy Barnard
ISBN 978-1-927852-22-4

Mise en Jeu and Mise en Geste is part of the caboose essay series Kino-Agora

Published by caboose, www.caboosebooks.net

Designed by Marina Uzunova and Timothy Barnard. Set in Cala type, designed by Dieter Hofrichter, by Marina Uzunova.

Cataloguing information for this volume can be found on the last page.

Printed in the United States of America.

Mise en jeu and Mise en geste

[The mise en geste of a character]

Back in the day Freud created quite a stir, proclaiming (demonstrating and substantiating) that a slip of the tongue and 'false action' [*Fehlhandlung*] are in reality neither a slip of the tongue nor false action, but one's true intentions breaking through 'masking action' [*Deckhandlung*], by which—owing to outward conditions, demands and circumstances—they are obscured, disguised, 'repressed'.

Along the same lines Konstantin Sergeevich [Stanislavsky] preached 'subtext' as the current of true meaning running parallel to the superficially conventional course of dialogue: true agenda under the cover of absolute appearances.

(Hemingway with his dialogues practically hits you over the head with it, whereas Chekhov gets there with impeccable understatement.)

With Konstantin Sergeevich said phenomenon is not tinged with the aggressive hues of 'repression', as in Freud, but the two are doubtless related.

Konstantin Sergeevich is, moreover, lacking the idea of these repressed motives 'breaking through' the surface.

Still, the palm of primacy is bestowed squarely upon 'subtext', peeking through the layers (the vestments) of visible text.

Subtext, as far as the Art Theatre is concerned, determines much of 'what gets acted'—and that's that.

And to a certain extent 'what gets staged', but only within the limits of 'what gets acted'.

The fact that this same phenomenon must extend—beyond the actor's psychological content and hence that of his actions—to the

totality of plastic, spatial and aural expression (realisation), of action as well as all the other elements of a production as a whole, is essentially ignored by these schools of thought.

Generally speaking, this is what happens in real life—when we act.

The difficulty arises when spontaneous action or intention must be furnished with motivation—justification.

This may be readily observed in an experimental setting.

There is a very simple hypnotist's trick.

Under hypnosis the subject is ordered to perform a certain task at a specific time after he is revived.

Upon waking he will do just that, precisely at the appointed time.

I remember one such experiment in Minsk.

A young lady was put to sleep. She was ordered to open the window precisely seventeen minutes after she came to.

She did.

Nothing 'magical' about it.

Merely a difference in degree. For through hypnosis one is able to 'neutralise' those strata of consciousness, those nodes or areas of the brain that regulate (stimulate, retard, mobilise to counteraction, etc.) the automatic response, i.e., everything that resists unconditional, automatic execution of external 'commands'.

Likewise, the basic goal of military 'drilling' is to remove any rational intermediate between a command and its direct (reflex) fulfilment.

This must be so automatised as to be more powerful and more effective than any other external stimulus, which might 'normally' dictate very different behaviour (basically—the efficacy of a command despite the instinct of self-preservation—as in an attack—to rush under a 'hail of bullets' or 'charge the bayonets').

There is very little room for reflection here; and the same is true of ideological 'intoxication' (similarly effecting automatisation of physical behaviour—by way of . . . self-hypnosis) or common physical intoxication, which impairs the analytical and rational faculties.

Roughly speaking, hypnosis paralyses the rationalising, self-determining faculty.

It achieves 'absolute obedience'.

Nor is there any mystery in its 'perfect timing': this is an innate quality, suppressed by higher-order functions, but easily trained to operate with utmost precision (just as the eye may be trained to judge distances with precision to rival measuring instruments; just as there is 'perfect pitch', etc.—here we have 'perfect timing').

It is thought that the 'sense of time' is to be found in the organism not in the mechanisms responsible for 'higher nervous activity' nor in its more primitive branches [*succursales*] but in the most basic strata—in the tissues.

The most curious aspect of this whole process, however, is the work of motivation performed by the patient as the appointed time draws near—particularly if the assigned task is counterintuitive in given circumstances (which is typically the case!).

Our young lady did not simply open the window; rather, a few minutes beforehand she became quite agitated.

At last she blurted out: 'Isn't it stuffy in here!?' (though it was nothing of the sort!)—at which point she made a beeline for the window.

The more 'absurd' the task, the more preposterous and more conspicuous the process of motivation will be.

So it is in real life, only somewhat more complex, so that the work of subtext and its dressing-up in 'motives' may range from the unconscious act to the calculated and deliberate masking of a true motive with a sham pretext.

Someone looking to finagle a dinner invitation will deliberately, 'casually' turn the conversation to the subject of food.

Also, a man suffering from alimentary dystrophy,[1] to give another example, will 'unwittingly', 'in spite of himself', steer the conversation back to food again and again.

The same is true of action.

The eyes of a hungry man, who has come on some unrelated business, will invariably be drawn to whatever food happens to be laid out on the table.

Put a man in front of a mirror and—no matter what he might be doing—you will witness his gaze returning obsessively to his own reflection.

Now.

Every motive has the habit of expressing itself directly in action (later we shall see how action—by way of *pars pro toto*—may be reduced to . . . a line of action, its 'schematic representation'—at which point we will be dealing with . . . the line of mise en scène!).

A young man has married a girl, and for the first time he brings her to his room.

Closing the door after her, he explains to her that the door is fitted with a 'French' lock.

'Locks by itself'.

This is 'empty information' and 'there is nothing to act' here, until we find a psychological key to this . . . lock—to this talk of the lock.

This 'key' is two-fold.

We find it first in the young man's character.

And second, in the storyline.

The young man (I mean the young man and the scene from Vinogradskaya's screenplay[2])—Makogon—turns out to be a selfish, possessive type.

And soon the clash of character will drive the young woman (the heroine in this story) to leave him. (Personal drama behind the events of the plot.)

The 'cloistering' mentality, directed at the young woman, whom he has 'taken' as wife—is entirely characteristic of the young man.

The lock, 'locking away'—'surfaces' in the very first conversation.

(Makogon exhibits traces of the same mentality that keeps women—'master's property'—locked up in harems.)

But the immediate motive—to lock away personal property (acquired by way of marriage)—is displaced, its tawdry aspect neutralised by this explanation of the locking properties of this special—to a simple girl from the countryside outright exotic—lock.

(A detail such as this safety lock in the door is 'revealing' of Makogon's character.)

How to act this episode? How to stage the action?

The secret to effective mise en scène—as opposed to life, which is largely a matter of abridgment and elision—is to unfold on stage the entire process (see our discussion of negating gesture, which explains the whole method in a nutshell—reclaiming the process from the binomial of logic and restoring it to the trinomial of dialectic: from intention–execution to the negation of negation[3]).

What will this look like in our case?

The whole of the interior process taking place inside Makogon must be transposed into action.

What 'gets acted' is not the scripted piece of 'information' about the lock, but the whole process that leads up to it.

The Art Theatre is aware of this on the level of 'action'—using an internal process to arrive at correct delivery.

We must do the same more broadly, on the level of mise en scène.

We say: it is in Makogon's nature to lock up the girl in a *terem*[4] (to use a more familiar term than harem).

Corresponding act: lock the door (shut her in).

Action: closing the door, turn the lock.

There are two possible interpretations: a deliberate locking of the door and the involuntary (automatic) kind.

Which interpretation shall we follow?

How are they different?

They correspond to different nuances of character. Our choice then will be determined by the nuance that we wish to impute to Makogon.

The first option is somewhat crass. Entirely crass, rather. Primitive and prurient, if you will. It will effectively read as: 'now that we're married, let's jump into bed'.

The second one is better. Flicking the lock automatically. Shutting himself in is probably in Makogon's nature generally. Let us follow the second option.

We have also said that the remark about the lock's special properties is a sort of 'camouflage', masking the true motive of the action around the lock.

For this 'camouflage' to appear, it must be made necessary. Necessary to mask the true motive. To hide the true motive behind seemingly innocuous 'information'.

Where shall we look for this necessity? To be sure, in her action.

She is overwhelmed by the 'opulence' of his private—from now on their shared—room.

The lock clicks.

It snaps her out of her daze.

Naturally, her attention turns towards the lock.

To be sure, there is no 'suspicion' on her part.

This lack of suspicion will serve all the more elegantly to cue his 'masking' comment, intended not so much to neutralise her actual suspicion as to disguise his assumption that she must suspect him.

(The way a guilty man always imagines that he is being watched.)

Hence a certain hastiness to 'cover up' the whole business with an explanation.

A moment to steady his nerves, then a pointedly calm and didactic account of the locking mechanism.

To emphasise this even further, she will, of course, ignore his explanations, absorbed once more in her enraptured survey of the room.

Incidentally, to stress the lyrical rather than materialistic nature of her delight, the actual 'opulence' of the room must be made if not exactly squalid, then at least as mindlessly conventional, uncomfortable and cramped as possible.

Thus the impulse to project internal conflict into sensible form, sensible fact, can generate a concrete situation—a unit of action, embodying and revealing the internal emotional mechanisms of particular characters in particular circumstances.

We might say that this is the initial transposition of the interplay of motives into concrete action. I would call it: *mise en jeu*—embodiment in action—transposition into action.

It is interesting to note that the resulting action schema turns out to be 'universal', as it were, capable of accommodating any 'intensification'.

It remains viable for any variation of character or intensity of interpretation of the scene, which, taken together, will then determine the genre and style of any particular staging decision.

At one extreme we will have the treatment we have chosen above—that of nearly fleeting action (this 'fleeting' quality may be

scaled down to 'practically imperceptible' by further de-emphasising the action: perhaps the girl will not turn around but merely flinch at the click of the lock, there may only be a barely perceptible caesura before his reaction, etc.).

At the other extreme—an interpretation that intensifies the scene by way of a melodramatic saturation of colours.

Let us imagine for a moment in place of the ordinary young man Makogon a kind of Romantic schemer on the order of Richard Darlington (from the eponymous play by Dumas *père*), a Richard Darlington about to toss his bride, who happens to stand in the way of his ambitions, from the balcony into the abyss below—and now we no longer hear the casual click of the lock, but the screech of the key, turned by a murderous hand. The victim turns around in terror, pleading with outstretched arms. And the remark about the locking mechanism now drips with bitter irony, as he stalks softly towards his doomed victim like a cat towards its prey, carelessly slipping the key into a slit pocket in his embroidered satin vest. Add to this that the young priest, who had married the pair (naturally, this is set in an era before there were such things as civil registries)—is an impostor, that the marriage certificate is forged, etc. We are in the thick of early nineteenth-century melodrama.

The quantitative difference of the intensity of emphasis on the schematic outline yields qualitative stylistic changes overall.

Thus a shift in the scope of action can push the scene as a whole beyond the bounds of realistic or naturalistic interpretation into theatrical or dramatic (melodramatic) forms wholly alien to it.

The example above has shown us how character and its characteristic conflict become sensible and visible by their transposition into elements of concrete action: into a new 'scenic' unit, born out

of the need to render sensible the inner mystery of the interplay of motives inside the performer.

Here the example is confined within the most general boundaries: those of a scripted situation.

And, as we have seen, these boundaries—while preserving all the principal features of an original schema—allow for any saturation and variation of characters, intensity of emotional 'resonance' of the screenplay and even the full range of stylistic approaches, from the subtlest greys to the shrill black-and-white palette of melodrama with its cartoonish villains on the order of Scarpia from *Tosca*, the Duke of Guise from the scene with the iron glove in *Henri III et sa cour*, or a character out of Eugène Sue or Krestovsky!

There is still a 'great gulf' between this rigorous but still highly generalised schema and a fully elaborated, strictly inevitable (given the unique individual qualities of the author—the director—the actor) mise en scène of a given episode; yet even as this process of elaboration advances step by step, the method will remain the same.

Everywhere and in every thing—not only in every element of a character's behaviour in an unfolding situation, not only in the act as a whole, but in the most minute element of performance (spatial, graphic, representational or rhythmic)—we will discern one and the same method.

A bend or a bow, a raising or lowering of the hand, a movement interrupting a phrase or a cry rupturing a movement, etc., etc., will likewise be made subordinate to the task of rendering motive and intention sensible, the only difference being that here the spatial arrangement of an individual's various parts, of an individual as a whole vis-à-vis another (a partner), or finally of an individual vis-à-vis his environment, will also serve as a legible inscription, revealing inner meaning and the interplay of inner motives.

Let us unpack this by analysing a chain of concrete events, such as invariably results whenever a passage—in our case out of a novel—must be transposed into a piece of real action.

We will take a passage from Dostoevsky's *The Idiot*—on account of the complexity and texture of its central character, as well as of the author's peculiar style, which, as we shall see, will assist us in teasing out the subtleties of transposing a written description into a chain of visually 'legible' acts.

The scene is of Parfyon Rogozhin's attempted murder of Prince Myshkin (Dostoevsky, *The Idiot*, part II, towards the end of chapter 5):

The two eyes from before, *same ones*, suddenly met his gaze. The man hidden in the recess had also in the meantime taken a step forward. For a second both stood facing one another, almost touching. Suddenly the prince seized him by the shoulders and swung him backward towards the staircase, closer to the light: he wanted a clear look at his face.

Rogozhin's eyes gleamed, and a mad smile twisted his face. His right hand went up, and something flashed in it; it never occurred to the prince to restrain it. He remembered only that he must have cried out:

'Parfyon, impossible!'

Then suddenly something gaped open before him, as it were: an extraordinary inner light illumined his soul. This moment lasted perhaps half a second; but he, nonetheless, remembered clearly and consciously the beginning, the very first sound of his terrible cry, which burst from his chest of its own accord and which no amount of force could have restrained.

... He had an epileptic fit ...

. . . the prince recoiled from him and suddenly fell backward,
right down the stairwell, smashing his head on the stone step.

We will limit our exercise to the section that begins with the words
'Rogozhin's eyes' and ends with 'Parfyon, impossible!'—and the
backward tumble.

I presume there is no need to give an account of Prince Myshkin's
character. Especially because here, in one of the novel's climactic
episodes, his whole character is summed up, literally in just a few lines.

Absolute fearlessness in the face of real danger as the knife
is raised over his head (no wonder the bearer of the 'paltry' sur-
name Myshkin is given the proud first name Lev[5]); moreover,
an absolute disregard for danger, as well as for practical necessities,
stemming from absolute preoccupation with a moral problem.

A knife is raised over him. But 'it never occurred to the prince
to restrain it'. An attempt is made on his life, but he can find no
other words, besides those expressing the moral implausibility (to
his mind) of such an act: 'Parfyon, impossible!'

And the terror—not of the knife, but of the moral abyss that
suddenly gapes open before him—is the final blow that brings on
his epileptic fit.

Actually, this character exposé is precisely what must be ex-
pressed through details of action and acts, which, drawing on
Dostoevsky's description, must be rendered sensible for the specta-
tor.

Whereas the first phase of our work, illustrated by the previous
example, we have termed *mise en jeu*, this next phase (the first having
been taken care of for us most admirably by the author himself) I
would venture to call *mise en geste*—transposition into movement—
into the actor's gesture and physical change of location.

The basis for any breakdown of an author's outline into concrete actions and events must always be sought in whatever is idiosyncratic, unique and inimitable in the original material.

Even as we take stock of all that is typical, general and universal, we must always be on the lookout for something that in given circumstances determines the individual quality of a character's behaviour as well as of the author's perspective on the events. It is in accordance with this perspective, after all, that the author fashions his character, draping a composite of many bits of reality in a unique interpretation that is the living persona of his character, his hero.

The key to the composition of this scene is coincident with a key aspect of Myshkin's character.

Myshkin—this Christ come down into the social milieu of the 1870s—is wholly opposed to it by the very cast of his moral character.

(I am unable here to enter into a philosophical assessment of the novel, its social roots or the social roots of Dostoevsky's worldview. Likewise an analysis of the reactionary basis of such a worldview would take us too far afield. We shall have to take the various elements of the given situation as they are posited and presented by Dostoevsky. A sociological analysis of individual works and a reinterpretation or re-evaluation of individual characters of the past will be undertaken in a separate study.)

Myshkin's internal—predominantly moral—opposition to others underpins the complete spectrum of his behaviour in the novel. But it is also to be found in the most minute details of his behaviour. These, echoing the direction of his thought and his notions of the correct order of things—notions fundamentally antithetical to theirs—are inevitably opposed in their manifestations to their 'common sense', are from their perspective absurd, 'idiotic'.

From Myshkin's perspective, it is not he, Lev Myshkin, who is in danger.

Rogozhin is in danger—dangerously close to destroying his soul.

Anyone else would take hold of the hand wielding a knife.

But... 'it never occurred to the prince to restrain it...'

Anyone else would fear for his life.

The prince fears for another man's soul: the soul of a murderer, who threatens him with a knife.

And the prince, who loves Rogozhin, cannot abide this terror, and he can only vaguely remember that 'he must have cried out: "Parfyon, impossible!"'—as though this denial might drive from his mind the terrifying thought that Rogozhin may be capable of murder, capable, moreover, of murdering the man with whom he had sworn brotherhood and exchanged crosses only a short while ago.

Curiously, the hero's characteristic behaviour and the author's characteristic literary technique appear to converge here in this incident.

Here the prince's conduct, wholly consistent with his inner worldview, which dictates action contrary to the prevailing logic of self-defence, coincides in a certain sense with the manner of 'inverse writing', a literary device characteristic of Dostoevsky's accounts of his characters' behaviour, even when it is not strictly called for or as deeply motivated as it is here.

Born of the author's deep inner need to sermonise, this device evidently becomes at times an end in itself, a manner, even a mannerism.

How else could we account for this venomous critique, delivered by Ivan Turgenev:

On one occasion the conversation turned to Dostoevsky. As everyone knows, Turgenev disliked Dostoevsky. As far as I can recall this is what he said at the time:

'Do you know what an inverse commonplace is? A man is in love, his heart is pounding. He gets angry, his face turns red. These are commonplaces. With Dostoevsky, everything is turned inside out. Suppose a man encounters a lion. What will he do? Naturally, he will blanch and try to run or hide. In any ordinary story, say a Jules Verne story, this is precisely what will happen. But Dostoevsky will say it backward: the man turned red and stayed rooted in place. This would be an inverse commonplace. It's a cheap way of passing yourself off as an original writer'.[6]

Prince Myshkin himself gives a rather accurate assessment of this peculiar quality of his own behaviour.

'I don't have a suitable gesture . . . My words are different, not suited to the idea'.

That is, no gesture that may be suitable—becoming—in a given situation.

His words do not correspond to his ideas.

In another place he speaks even more to the point:

'I have no gesture . . . I always have the opposite gesture'.

Unbalanced gesture, excessive gesture, gesture 'with no sense of propriety' (again, his own words) implies also that not everything can be put into words, into a fully developed expression of ideas, which seem to overwhelm him.

In any event, what we have here is not an 'inverse commonplace' for the sake of a bit of unexpected literary sauciness; rather, Prince Myshkin's conduct, 'inverted' vis-à-vis accepted norms of behaviour, is wholly grounded in the peculiarity of his character.

And the motives underlying the 'inversion' of Myshkin's behaviour in this scene must serve as the centre of gravity of our interpretation, from which shall emanate all the elements of the mise en scène of the entire 'confrontation' episode.

Indeed, this will be that inimitable, idiosyncratic and extraordinary aspect of the scene, which we ought to take as our starting point, subordinating to it the overall structure of this otherwise banal incident of some failed effort to do away with a certain lucky specimen of a dwindling aristocratic clan.

Keeping all that in mind, let us turn to the mise en geste.

To this end, we will rewrite this episode as a sequence of actions and utterances, i.e., as a kind of 'script' of the original passage.

1. Rogozhin's eyes gleamed.

2. A mad smile twisted his face.

3. Rogozhin's right hand went up.

4. Something flashed in it.

5. It never occurred to the prince to restrain it.

6. The prince cried out: 'Parfyon, impossible!'

7. The prince let out a terrifying scream.

8. The prince had an epileptic fit.

9. The prince fell backward, smashing his head on a stone step.

What's next?

That is, where do we start?

One method would be to follow the action step by step.

This is the 'creeping' method, wherein the individual solutions of each step will determine the overall movement of the sequence.

The correct method is elsewhere.

The solution begins with the central (leading) element.

The leading element is the one that more than any other epitomises the subject and the meaning of the episode.

It too will bear the stamp of that peculiar inimitable quality of the episode I mentioned earlier.

In our episode this is element no. 5, which we have already discussed at length: 'it never occurred to the prince to restrain it' (*the hand*).

How we resolve this key moment of action will determine all the rest.

Everything that comes before will be its groundwork.

Everything that comes after will be the segue that propels this motif towards the explosive climax 'Impossible!'

With this—fifth—link in the overall chain of action we will begin our composition of the action, our transposition of the action into a sequence of action-movements—our mise en geste.

Taking the fifth element as a stage direction—does it contain enough concrete information for us to act out what it says?

Upon closer inspection we find that it not only lacks any such information, but that it presents a far more 'tragic' state of affairs— it says nothing at all about what the prince is doing, indicating only what he is *not* doing: the prince is not thinking of restraining the hand.

This sounds wonderful as a piece of prose.

It affords a very elegant descriptive nuance, but unfortunately this nuance has no direct counterpart in action, gesture or visual representation.

The plastic effect of an 'unlit window' as opposed to 'dark window' is much harder to achieve in strictly visual terms than this simple nuance of the written word.

One way to approximate it would be to show several lit windows one after the other, followed abruptly by a dark window: indeed, there is a very good chance that such a window would be read precisely as 'unlit'.

We can assume, at any rate, that 'negative representation' may evidently be built up by way of showing the opposite as the clearest embodiment of the negation of whatever is being asserted. Let us look along the same lines for some clue as to how we might use a positive act to express the idea of negating some other act.

We have already agreed that the negation of an act will be expressed most distinctly in the execution of another act diametrically opposed to it.

But how could we assert by plastic (and spatial) action alone that this movement is not simply other (albeit opposite), but first and foremost a negation through opposition of the first, which in the text is coupled with the negating particle 'not'?

Presumably the negating action must be identical to the original in its outward contour, while directly opposing it in essence.

If we suppose that we are at least partly right with the respect to 'unlit windows', then this is precisely the principle at work there.

The contour of the lit window and that of the unlit window turn out to be the same, and this identity of contour—coupled with the opposition of the aperture within—suggests the opposition of their contents, not so much in terms of the ready result of opposite qualities (light–dark), but in the dynamic act of negation of one by the other (lit–unlit).

Now let us see what our case might look like if we start from these premises. The stage direction 'it never occurred to the prince to restrain it' surely conceals another action, which he does perform, and which preoccupies him at the time. What might it be?

Now, strictly speaking, the idea that those 'same eyes', which have pursued the prince from one page to the next in the preceding passages, are Rogozhin's eyes, that it is Rogozhin, has not yet occurred to the prince. More accurately: Rogozhin's eyes have already 'entered' the prince, but have not yet reached his conscious mind. Their identity remains a mystery. Even more accurately: it has (or had) already occurred to Myshkin that the one who has been consistently identified as 'a man' ('he saw... a man', ' this man seemed to be waiting for something', 'the prince could not get a clear look at this man'), the owner of the 'stalking eyes'—is none other than Rogozhin.

'He suddenly sensed with utter and most irresistible conviction that he had recognised this man, and that this man is none other than Rogozhin...'

The prince refuses to believe it.

So much so that, furnished with proof, he still cries out:

'Impossible!'

But before that, to make sure that it is not in fact Rogozhin, 'the prince rushed after him up the staircase... the prince seized him by the shoulders and swung him backward towards the staircase, closer to the light: he wanted a clear look at his face'.

Until then the suspicion that it is indeed Rogozhin—rather than the 'irresistible conviction', which the prince refuses to admit as absolute fact—is limited to the observation that 'the two eyes from before, *same ones*' (as Dostoevsky emphasises in the text)—are the same eyes that have followed him all through Petersburg, from the train station to Nastasya Filippovna's house, and from the Petersburg Side to the Vesy Hotel...

And so, evidently it is the moment in which the prince at last becomes fully convinced that it could be none other than Rogozhin—

note that this moment is followed directly by the total emotional discharge ('Now all will be made clear!') of the prince's exclamation and the terrifying cry that signals the onset of his fit—that lies concealed beneath that brief remark, wherein 'it never occurred to the prince to restrain' the hand raised over his head; in this moment the prince must be thinking about the fact—recognising as fact—that the man before him is none other than Rogozhin.

It is really a marvellous conceit on Dostoevsky's part that the prince feels 'irresistible conviction' that it is Rogozhin before he has a chance to see his face clearly, while the absolute certainty that it is 'none other' than Rogozhin comes only after he has actually seen his face (a delay long enough, at any rate, to allow Rogozhin's eyes to gleam, his face to twist in a demented smile, and his hand to rise).

And so we have determined what the prince is actually doing at the moment when anybody else would be trying to restrain the menacing hand. He is peering into Rogozhin's face, scrutinising it, and at last realising that it is truly 'none other than Rogozhin'.

Now we know just what the prince was doing when he was not restraining Rogozhin's hand (insofar as our reading of this passage goes, which we do not consider compulsory for other directors, who may well interpret it otherwise, in accordance with whatever Dostoevsky happens just then to whisper in their ear!).

He was doing two things:

scrutinising and recognising.

Now, these are already concrete, positive acts, which we can discuss in concrete terms.

What shall we say about the first of these actions (or the first phase of the action, culminating in the second—recognition)?

How shall we stage it in terms of movement?

Without getting too fancy, this scrutinising ought to be done in the most straightforward, most naïve, i.e., most obviously literal manner.

In this case such scrutinising would mean drawing near the object of one's scrutiny—that is, Rogozhin.

Such a movement would be entirely consistent with Dostoevsky's 'formula', as Turgenev had framed it so ungenerously—but essentially correctly.

A man is threatened with a knife.

Any reasonable person would attempt to restrain the hand wielding the knife.

Or recoil from it, at the very least.

In Dostoevsky it would never occur to him to do either of those things.

Moreover, he would move towards the killer.

Not in order to restrain him.

But to do what is most inappropriate in such a situation: to get a good look at him.

Taking this as a starting point, how will we direct the prince's eyes, his little hands and feet?

The eyes will probably squint.

This is natural for scrutinising. The squint is a kind of stopping-down of the eye. When the aperture is stopped-down, as we all know, the image is brought into greater focus. And what scrutiny implies is precisely a kind of mental focusing of the visual impression.

Moreover, recognition—and here it also happens to be astonished (shocked) recognition—in given circumstances, once again most lapidary in their expression, will probably be acted as eyes widening in astonishment. (The dynamic of the very term 'astonishment' has nothing in it to suggest shrinking, cringing, squinting!)

The squinting, scrutinising eyes just before—a most fortunate preliminary state, affording a most striking transition into astonishment, from squinting to gaping wide. (These considerations already enter into the realm of external expressive means.)

And so, rather than recoiling from the murderer we have the opposite—leaning in for a closer look.

Moving on.

What are the prince's hands doing, or rather what shall we have them do?

Presumably they are also acting the motif of the proposed scrutiny.

A man stands before a shell that is ready to explode.

Instead of running away from it he will lean towards it.

To get a closer look.

Is this the limit of 'inverse behaviour'?

Is this the 'final word'?

The last stop?

Of course not.

To approach the limit of expression our man will . . . put out his hand.

Touch the shell.

If we replace 'man' with 'child' the entire act will lose its attendant tinge of pathological irrationality—the act will take on the character of child-like innocence, naiveté, immediacy: i.e., the very qualities that betray the child-like purity and naïveté of the prince's soul.

It is a child's gesture, then.

The gesture of a child who might run his little hand over a lethal blade, unmindful of its destructive force, stroke the head of a little green snake, unsuspecting of the venom in its bite, tousle the fur of a wild beast, oblivious of its snarl.

And which movement of all that are available to us could express most fully this 'knows not what he does' in the face of mortal danger?

Naturally, a drifting hand (attention wholly focused in the eye!) 'knowing not what it does' will come to rest beside the dagger, touching or nearly touching the razor-sharp, gleaming blade.

Now let us look at the resulting image.

The prince is pressed against Rogozhin.

His hand rests upon the hand wielding the knife.

Now, what would have been the contour of the movement if in fact it *had* 'occurred to the prince to restrain [the hand]'?

He would have leapt on Rogozhin (pressing against him).

And . . . his hand would come up against Rogozhin's hand (or knife).

In other words: spatially, the contour is one and the same.

Whereas in terms of the movement's inner content—two sharply—diametrically—opposite acts.

Active resistance.

And astonished scrutiny.

In terms of outward contour—the traditional picture of a man neutralising an attack; in terms of inner content—the most unexpected action at that moment: peering into a killer's face, completely oblivious of the most immediate (aggressive) theme of the entire scene.

Is this not precisely what we had sketched out earlier when we set out in search of our image?

It is perfectly obvious that the 'coincidence' here extends only to the general outline and basic arrangement of bodies—internally everything is in direct opposition, beginning with emotional content and ending with the degree of muscle tension.

'Lit windows' and 'unlit windows'.

Marvellous!—so the reader might say, if he is a gracious sort.

If he also happens to be an attentive sort, this 'marvellous' will take on an ironic tone, as it will be promptly followed by a sly:

'Marvellous, indeed, but why have you made Rogozhin—a lefty?!

Because the prince's 'groping' hand will surely be his right.

Because, knowing your system and your style, you will surely assign this automatic, involuntary action to the right, the active hand.

This will surely heighten our impression that the prince's attention has been channelled wholly to his squinting eyes.

And in that case it would have to fall upon Rogozhin's left hand, since he is facing the prince!'

Here is what I would say to such an attentive reader:

'You are far too hasty in drawing your practical conclusions. For one thing, however, I am deeply grateful to you. That is, for pointing out that (all other decisions being evidently acceptable to you) at this point we must position the knife against the prince's right hand. Apart from that you are overly rash. A lefty Rogozhin is not the only solution to this problem, to this puzzle!'

Certainly, our sole task now is to have the raised knife come up against the prince's right hand.

But we can get there easily enough without condemning Rogozhin to a lefty's lot.

In fact there is any number of ways to raise a knife.

And among these we can readily find the sort of variation that will suit us.

What is more—it will turn out to be more consistent with Rogozhin's style and character than the most basic direct upswing, which would have thrown up his hand in a straight line, putting it opposite the prince's left.

This would be a swing of the right hand up towards the left shoulder, from where the blow would be delivered along a diagonal, left to right and slightly downward—a 'backhand' blow, evoking in its direction and movement not only the idea of brute force, but also, to some extent, of self-defence and reinforcing, we might say, the motif of furtiveness, which follows Rogozhin throughout—as he ducks and disappears in a crowd, conceals himself in a recess, hides behind the gesture of exchanging crosses, etc.

A straight lift of the arm, 'open-visor', as it were, would expose the chest.

A sideways lift across the chest—protects it.

Rogozhin hides himself behind his arm.

And so, the insidious blow, delivered at an angle, packs even more brute malice and treachery.

In this case, the overall trajectory of the gesture will be [a sharp zigzag: Rogozhin pulls a knife laterally from under his cloak (left to right, or A to B); he raises it diagonally over his head (right to left, or B to C)].

This two-step movement has also the advantage of extending the path travelled by the knife; by breaking up the movement (at B) we emphasise its second (principal) segment BC: the path from B to C would then be the clearly legible, gleaming stroke of the knife, visible only as a flashing trace, which we hear in the text: 'something flashed in [his hand]'.

The fact that the lower portion of Rogozhin's face ends up covered by the arm also works to our advantage.

Our focus is at all times on the eyes. For an instant...

'a mad smile twisted his face'.

Only to be covered up again by the elbow.

Once more the glow of Rogozhin's malice is wholly concentrated in the eyes.

And Rogozhin himself is like a beast lying in wait in his jungle, behind the protective barrier of his own arm.

Upon this menacing arm, barely touching it, fall the prince's slim fingers, splayed, powerless in their astonishment—their almost ethereal weightlessness intercepting and negating the murderous threat of the knife in its brute force.

Here is what the sequence would probably look like. The heavy swing of the arm, from waist level (framed slightly from above) to the shoulder level of Rogozhin's stocky figure, is followed by the prince's fluttering hand, alighting upon it in a gesture of astonishment.

Then comes the prince's face moving in, evidently for a closer look at Rogozhin. Rogozhin's whole frame cowers behind the elbow, as it were. The prince peers at him.

Recognises him.

How can we communicate most effectively the idea that the prince has recognised Rogozhin?

To be sure, by doing everything 'just as it happens in real life'.

And how does it happen in real life?

With an exclamation.

And what sort of exclamation will make it perfectly clear that one has recognised a particular person?

An exclamation of the name.

Indeed, the name—Parfyon—is right there.

Clearly, the name—in the exclamation 'Parfyon, impossible!'— is to be set apart here for this very purpose.

And any actor will thank you for it, because there is no way to deliver the line 'Parfyon, impossible!' in one breath, without breaking the phrase up.

Not only because of the phonetically hopeless 'n-n' (Parfyon, ne),[7] but because there is simply no way to deliver this phrase meaningfully without a caesura.

At 'Parfyon' the eyes gape open in astonishment.

The eyes are filled with terror.

Not for one's own fate, but for Parfyon's.

Then the motif 'impossible!' comes in, as something too horrible to believe.

Terror swells, reaching the breaking point where all one can do is cry out 'Fie!' 'Away!' 'Be gone!'—coalescing into 'Impossible!'

Into an 'impossible!' that reads as 'I refuse to believe it!', 'can't allow it', want to 'dispel the nightmare'.

The exclamation is the discharge that comes at the peak of terror.

Its image is composed of dilating pupils, hair standing on end, fingers splaying, arms extending out.

At this point we may wish to say something about the characteristic ambiguity of expression: terror, like any other affect, is realised in two opposing aspects—to hide, to bury one's head (ostrich), to shrink, to disappear; at the same time, just as often we get bulging eyes, crawling skin, hair standing on end, mouth gaping, arms drifting apart.

Spatially the prince moves away from Rogozhin, as from a source of terror; the scope of the terror emanating from Rogozhin is described by the prince's spreading arms.

In a moment the terror will reach its apogee and its radiating movement will collapse into the zigzag of the arm: 'Impossible!'

Zigzag? Who said zigzag? Why a zigzag?

This zigzag is the head's movement, shaking in refusal, transposed onto the right arm.

The negating movement of the head, which had at one time served to detach, to free one's teeth from the revolting taste of something snatched up by mistake. (Anything that has penetrated past

the teeth into the gullet is subject to the next stage of rejection—i.e., ejection from the mouth, horking up, spitting out.)

For the hand it is a gesture: to erase the terrifying image standing before one's eyes, cross it out—not with determined, diagonal strokes, but with a frightened, mincing lateral movement, accompanied by a muttered: 'Fie, fie, vanish, be gone!'

The head continues to act the motif of terrified fascination— the face, stone-dead like the Gorgon's, the eyes widening in terror, unblinking, are moving away from Rogozhin—the source of terror.

The right hand sketches rapid zigzags of refusal in the air, powerless to break the steel cord stretched between the two sets of eyes. The feet move away, the body turning to stone from the eyes down to the very legs...

The zigzag grows in its nervous intensity. Its trajectory—as though it were the stuttering onset of the imminent, terrified 'im...'— the first sound of the categorical denial of the terrifying 'apparition', the cry of 'impossible!'

And now this cry bursts from his lips!

But let us turn back for an instant.

To the point which, on account of the presumed character of the movement, we had described graphically as the radiating sensation of terror, from the actual circle of the dilating pupil, the widening rims of the eyelids, the eyeballs seemingly straining to break free, to the slackening jaw, hair standing on end, arms spreading apart (clearly, the plastic idea of terror moving outward in concentric circles is not as arbitrary or unexpected as one might have suspected).

The feet are rooted in place.

Although we have spoken earlier of 'moving away' from Rogozhin, this is only a leaning back (at the waist), straining with all one's might to distance oneself from the source of terror, a leaning

back that seems to impart a general impetus to all the elements of the upper body, on the verge of scattering in every direction (in an outward radiating motion).

But now this system of 'radiating circles' becomes a convulsive zigzag of the refusing motion.

At the same time the feet, breaking contact with the ground, drag the petrifying body, stiffening to a plank, away from the source of terror.

Such a radical collapse of an entire system of expressive manifestations into a radically different system cannot take place without a new impulse.

So, the rapidly intensifying inertia of one system of movement cannot suddenly leap into a different aspect of behaviour without some new impulse. And, considering the paralysed state of the victim of terror, the new impulse at this point cannot come from within, from interior conflicts prompting a break in the realm of exterior manifestations, thereby signalling the triumph of one set of motives (struggling with the rest) over others.

We need an external jolt.

Perhaps the closest thing is a strictly physical shudder, its physiological zigzag paving the way, as it were, to a mental zigzag, acting as its ideal vessel, which may receive an outpouring of mounting emotion on the verge of breaking out into the pulsation of physical manifestation.

Is there some moment in the text to accommodate this, some corresponding arrangement of objects, a corresponding moment of action that might trigger such a convulsive spark, which in turn could connect with the inner impulse of emotion straining to break out and burst into an ever-widening zigzag of refusal in the right hand?

There is!

Of course there is. And it can appear (as it well should) in the interaction of already existing details and objects, in the expressive possibilities of some new orchestration of these elements, without our having to introduce new elements, motives or details.

From the dilating pupils to the arms drifting apart with their splaying fingers we have described the radiating concentric circles of mounting terror.

Consequently, the arms and the fingers in their movement trace the apogee of this phase.

Let them move (coming at the end of a whole chain of action: pupil—eyeball—eyelids—superciliary arches—hair—jaw, etc.).

Moving along, the tips of the splayed fingers will graze . . . the knife's blade.

A cut? The sharp edge of the blade?

No! Only the chill.

We only need something to trigger a spasm.

What could be more natural?

The sensation of the cold metal of the blade.

A momentary shock.

The abrupt end of one phase.

And at the same time a spatio-rhythmic 'grace note' for the whole movement scheme of the second phase.

And after the motif of the eyes—the second motif from the nightmarish wanderings through Petersburg: the motif of the knife.

And why does this work out compositionally?

If the first motif—Rogozhin's eyes—entered Myshkin's action by way of vision, then this second motif—Rogozhin's knife—enters the action through touch—shudder—spasm!

This is just how we had staged the fragment 'peering–recognising': its first component—the action of the scrutinising eyes, the

second—a different dimension—a different sphere of expressive means—the cry of recognition ('Parfyon!').

Thus from firmly clasped links we forge the chain of action.

We had left it momentarily at 'impossible!'

The next step is the howl, the epileptic fit, the tumble down the stairs with the head smashed against the step.

We need another jolt.

An external impulse.

Going directly from the phrase to the howl—we get an inevitable interference: 'impure' entrance, poorly articulated joints of action.

Plus... a forgotten partner.

The jolt—the external accent—may be of two kinds: direct, forceful, immediate; but it may also be the opposite, something we might call a counter-accent.

Which of the two is more appropriate here?

The second, of course!

Why? Because an accent introducing new action simultaneously offsets it, and by opposing it in character (contrasting with it) it does so more distinctly, legibly, intelligibly, palpably.

We are about to hear a cry.

What shall precede it? Its opposite, of course. A counter-accent. Something mute.

Something passive—the opposite of the active quality of 'the sound of his terrible cry'.

And what could be more appropriate than transferring this element to the partner's action!

For, among other things, did we not locate the first external impulse in the initiative—albeit passive—of the prince's trailing fingers, as they come against the icy steel of the knife blade?

And it is just as natural to delegate the new impulse to an equally passive act of Rogozhin's, its very passivity triggering now—post factum!—a reaction that the most aggressive moment of his act at the most climactic instant could not trigger.

Rogozhin's raised hand droops downward.

It echoes his astonishment at the prince's extraordinary behaviour.

And just then, once more 'contrary to reason', not in a moment of danger, not at the upswing of the lethal knife, but at the knife drooping helplessly and senselessly, drawn down by the arm that has lost its will to strike, comes the explosion—an 'inverse reaction', this time 'direct' in relation to the knife, but 'inverse' in relation to its present function.

Until now Prince Myshkin could see the knife only in Rogozhin's eyes, in the depths of his soul—in the mad twist of his smile, in the gleam of his eyes. The proximity of these two phrases is deliberate: 'Rogozhin's eyes gleamed', 'something flashed' in his hand. For the prince this something is not yet a knife; for him it is—like the gleam of Rogozhin's eyes—merely the lightning flash of murderous intent.

But not a knife. Not the fact. Not the act.

A transgression in thought, but not yet in concrete deed.

Only at the fall-off of the scene comes the prince's sudden realisation that the sin has been committed not only in thought, but also in the premeditated evidence of the icy steel of the murderous weapon.

The slowly (helplessly) drooping knife is a murderous reply to Myshkin's 'impossible!'

'Wrong: it is so!'

And here the prince breaks down.

To Rogozhin's confused, helplessly mute gesture comes the response of a terrible cry—epileptic fit—fall down the stairs.

And here, just before the fall—compositionally necessary as contrast, and emotionally inevitable—the eyes shut before the knife.

His whole body contracts.

A hysterical contraction into a ball.

And the savage cry, bursting from a crumpled up man, a cry that seems to pierce the air, twisting the whole man upward, only to tear him from the grip of balance and tumble him backward, head first, down the staircase...

Concluding our analysis, we will say that we have tried as best as we could to transpose the inner contents of our character's thoughts and feelings not only into corresponding acts, but also into elements of the form of these acts, into the very movement (and often into the very orientation of movement vis-à-vis another or others) complementing and continuing the exposition of this inner content.

In this we have once more followed Dostoevsky's technique and method.

An act in Dostoevsky—in his account of it—is not merely an action prompted by a given situation.

Rather both the act and the form (often the image) of its execution, besides the strictly factual account, possess also the background—the 'subtext', if you will—of the true meaning of the act (true content), emerging especially distinctly in the visual and plastic presentation of the superficial action, generally capable of taking on any realistically plausible form, but given here in the only possible form that captures its inner content.

'Superficially' the fact that Rogozhin and Myshkin walk on either side of the street as they approach Rogozhin's house for their final encounter with (the already murdered) Nastasya Filippovna, would surely be motivated by the instinct to ward off suspicion.

(We may recall all the other precautions taken by Rogozhin with respect to the janitor and Pafnutyevna.)

But the true 'content' ('subtext') of this extraordinary mise en scène is the emerging inner dynamic between Myshkin and Rogozhin as they move towards their final interview—the rivals' reconciliation beside the victim's body.

I will deliberately quote someone else's analysis of this episode to avoid accusations of 'rigging' the interpretation to suit the theory.

Rogozhin follows Myshkin into the hotel.

After a terse 'Lev Nikolaevich, best you come along', they proceed to Rogozhin's house in Gorokhovaya St.

The following interpretation is paraphrased from A.L. Volynsky's book on Dostoevsky:

> Suddenly Rogozhin stopped, looked at him, thought some and said: 'Tell you what, Lev Nikolaevich, you go this way, right to the house. And I'll walk on the other side. And see that we go together.' They will walk to the house, where Nastasya Filippovna lies murdered, on opposite sides of the street, divided by the roadway, but keeping abreast of one another. . . . Rogozhin and Myshkin were divided by life, because life, inasmuch as it partakes of the private, the prideful, the passionate, divides people. United by mutual affection, by something lofty and invisible, they were drawn into rivalry on account of Nastasya Filippovna. Now Nastasya Filippovna is no more, but this is still a secret—a solemn secret, and the time has not yet come for it to be revealed before the world, before the street. Together they will enter that house, where there is no longer anything to separate them, but here in the street they must keep apart. They will walk on the opposite sides.

And that is how they proceeded, looking over at one another, filled with frightful agitation. In this brief episode we can sense the author's own feverish throbbing. Myshkin and Rogozhin walk in parallel, checking on one another's progress, come together and separate again. . . . This terrifying night . . . they spend side by side, delirious . . . their love for one another thoroughly purified, rejuvenated . . .'[8]

This in no way endorses the general opinions on Dostoevsky and his works expressed by Volynsky in his book—opinions wholly adverse and alien to us, to our times and to our understanding of Dostoevsky and his art.

We are concerned strictly with elements of scene composition, which Volynsky has analysed most competently.

Nor am I in agreement with his assessment, slipped into the analysis, of the character of this mise en scène:

'Here begins a strange, fantastic play of symbols, wherein Rogozhin's intact soul emerges in all its majesty—that plain native force with its hidden love for allegories deep and wise . . .'

This assessment is all wrong. To begin with, there is not the slightest trace of love for 'allegories deep and wise' to be discerned in any of Rogozhin's actions; nor are there any 'half-glimpsed fantasies' which might 'on the eve of his spiritual awakening' disclose 'all his intelligence and all his faith'.

The bizarre mise en scène invented by Rogozhin for their journey to the house is perfectly logical as a matter of circumspection, as we have said earlier.

The 'background', described here rather unfortunately as 'allegorical' or as a 'fantastic play of symbols', must be attributed rather to the 'principal director' of this event—the author himself, the

'director' who also makes Rogozhin give his orders for the walking arrangements.

And by means of this peculiar diagram, which dictates the progress of a realistic event, the peculiar diagram that peeks through the mundane fabric of the event—he, the author, reveals (half-reveals) to us the innermost, deep-seated bonds between the characters.

Movement in the same direction.

Along paths that have not yet converged.

Parallel paths.

Paths which, contrary to mathematical logic, but by virtue of the logic of human emotions may nevertheless—after approaches and separations, after checking on one another's progress, crossing and re-crossing to and from one another—in the end be capable of converging, coming together, uniting.

This is no allegory, no symbol.

But a precise inscription of paths, figurally cloaked in the form of sidewalks, and through the lineaments of these robes speaking to us of the living, pulsating bond that unites these two characters.

Here I would introduce a semantic distinction.

I would use the terms 'representational' and 'figurational'.

I would say that representationally this movement along the opposite sidewalks is a precautionary measure.

But figurationally it is a superb use of mise en scène to communicate the essential bond between these two people, moving towards the denouement of their relationship—the novel's denouement, which turns out to be a brotherly reunion over the corpse of their beloved, who was at the root of their quarrel.

I chose this example not arbitrarily.

But instructively.

These two planes—each strictly consistent with the logic of its respective sphere, the representational and the figurational planes—are the two indispensable elements of any genuinely expressive mise en scène.

Such a mise en scène always contains a general description of the characters' movements and actions, as demanded by the logic of their activities in a given situation—this is the superficial, representational plane.

And the same mise en scène, as a plastic schema, must also communicate spatially the inner dynamic of the characters' relationships, which is the inner content of a scene.

How this is accomplished through the introduction of corresponding elements of action, capable of revealing inner motives, we saw in the first example with Makogon.

How it is then transposed into lines of movement and their actual spatial inscriptions we saw in the second example (Rogozhin's attempted murder).

How both of these places peek through one another in the mise en scène we described in the scene with the sidewalks.

It remains for us to examine an analogous incident, where we, now as metteurs en scène, will have to look beneath the surface material of a situation for the sort of figurational schema of the mise en scène that Dostoevsky so brilliantly traced for us in *The Idiot*.

For the sake of methodological clarity let us turn once more to the classics, this time choosing an episode that is even more visually striking, plastically more clear-cut.

[Mise en scène raisonné]

Quite some time ago—in the early thirties—I offered the students in one of my directing classes at the Film Institute a script-

ing exercise based on a passage from Balzac's *Le Père Goriot* (1834–35).[9]

The passage in question concerns one of those unforgettable episodes in the novel, as anyone who has read it even once will readily attest.

I am referring to the scene of the arrest of the mysterious and all-powerful escaped prisoner Trompe-la-Mort ('Cheat-Death'), who has been living under the assumed persona of a good-natured salesman and bon-vivant M. Vautrin at the proper and respectable boarding house of Mme Vauquer.

The episode is famous for its defiant indictment of bourgeois society, delivered by that infernal genius and leader of the underworld against an even more criminal world of bankers and crooked financiers.

Here––with some elisions––is the main section of that episode, which my students were asked to develop into *mise en scène*.

'By my word!' said Bianchon, 'just the other day Mademoiselle Michonneau was speaking of a gentleman called Trompe-la-Mort; that name would suit you well'.

Those words struck Vautrin like lightning: he turned pale and shuddered. His magnetic gaze fell like a beam of sunlight on Mademoiselle Michonneau, whose knees buckled under that burst of willpower. The old maid collapsed into a chair. Poiret, sensing that she was in danger, hurried to step between her and Vautrin, so full of rage and malice was the convict's gaze, as he let fall the good-natured mask that had hidden his true nature. Still understanding nothing of this drama, the lodgers stood frozen in astonishment. At that moment they heard the sound of footsteps coming from the street and the clatter of soldiers' rifles on the pavement. As Collin's eyes mechanically scanned the windows

and walls in search of an escape route, four men appeared in the doorway of the sitting-room. The first was the chief of police, the other three were his officers.

'In the name of the law and the king', said one of the police-men, the rest of his speech drowned out by a rumble of aston-ishment.

Then the dining-room was plunged into silence, the lodg-ers stood aside, making way for the three men, each of whom gripped a cocked pistol in his pocket. Two gendarmes, who had followed the police, stood at the entrance of the sitting-room, and two others appeared in the doorway that gave out onto the staircase. The sound of footsteps and the clang of soldiers' rifles came from the gravel path that ran along the front of the house. There was no hope of escape––all eyes instinctively turned on Trompe-la-Mort. The chief marched up to him and struck him on the head so violently that his wig came off and Collin's head appeared naked in all its vileness. Set in a brick-red crop of hair that lent it a frightful aspect of violence and cunning to match the powerful torso, the head and the face glowed, as though illum-ined by the glare of hellfire. At once they had grasped the whole of Vautrin, his past, his present, his future, his ruthless creed, his cult of self-interest, the majesty conferred on him by the cyni-cism of thought and deed and the indomitable strength of his body. Blood rose to his face, and his eyes gleamed like a wild cat's. He sprang back with ferocious energy and let out a great roar that drew shrieks of terror from the lodgers. At this leonine start the officers availed themselves of the general commotion to draw their pistols. Catching the glimmer of cocked hammers, Collin saw the danger and at once gave a show of superhuman strength. A horrible and majestic spectacle! His face underwent

a transformation that could only be compared to that of steam in a boiler with pressure enough to blow up a mountain, which instantly subsides when it comes into contact with a drop of cold water. The drop of water that cooled his rage was a thought that flashed like lightning. He smiled and looked at his wig.

'This is not one of your polite days', he said to the chief of police. And he held out his hands to the gendarmes, beckoning to them with a nod of his head. 'Gentlemen, bring your cuffs or shackles. I call to witness all assembled here that I have put up no resistance'. A murmur of admiration, elicited by the quickness with which the lava and the fire of this human volcano emerged and receded in turn, ran through the room.

(...)

The prison house with its customs and its language, with its abrupt shifts from bemusement to terror, its fearful grandeur, its chumminess, its depravity was all at once revealed in those words and through that man, who was no longer a man, but a specimen of some degenerate race, of a people both wild and intelligent, fierce and cunning. In an instant Collin became an infernal poem that painted the full spectrum of human sentiments, except one--repentance. His gaze was that of a fallen archangel, bent on eternal war. Rastignac lowered his eyes, accepting this illicit kinship as an expiation of all his wicked thoughts.

'Who sold me out?' said Collin, his fearsome gaze scanning the crowd. And coming to a halt upon Mademoiselle Michonneau: 'It's you', he told her, 'you old bag, you nearly gave me a stroke, you minx! A word from me, and you'll have your throat sliced open in a week's time. I forgive you, a Christian that I am. Anyway, you're not the one that sold me out. But who?-- Ah! Ah! You, rummaging up there', he cried out, hearing the

detectives going through his drawers and collecting his things. 'The birdies flew the coop yesterday. You won't find a thing. My ledgers are all here', he said, striking his forehead. 'Now I know who sold me. It must have been that scumbag Fil-de-Soie. Is that right, old grabber?' he turned to the chief of police. 'That would go all too well with our banknotes' hiding out up there. Not any more, my little gumshoes. As for Fil-de-Soie, he'll be buried in a fortnight, I don't care if you put the whole police force out to guard him.--How much did you pay this little Michonette?' he asked the policemen. 'A couple thousand? I'm worth more than that, you rotting Ninon, Pompadour in rags, Venus of Père-Lachaise. If you had told me, I would have given you six thousand. Ah, you didn't think of that, you old fleshmonger, or you would have come to me. Yes, I'd give that much to save myself the unpleasant journey, which will cost me a good deal of money to boot', so he spoke as they were putting him in cuffs. 'These boys will have a good old time, dragging the whole thing out to no end, just to wear me down. If they just sent me to prison I'd be back in business in no time, in spite of our little boobies from the Quai des Orfèvres. Why, down there they'd turn themselves inside out to save their general, old Trompe-la-Mort! Is there anyone among you that has ten thousand brothers, ready to go to any length for your sake?' he demanded proudly. 'There's goodness in here', he said, striking his chest. 'I've never sold a soul! Look, you old bag, look at them', he said, turning to the old maid. 'They're terrified of me, but they feel nothing but disgust for you. That's what you get!' He paused to survey the lodgers.

'What fools you are, all of you! Never seen a prisoner before? A prisoner like Collin, who is here before you, is not so cowardly as the common lot, and he stands against the dismal sham of

the social contract, as Jean-Jacques put it, and I am proud to call myself his disciple. In short, I stand alone against the government with all its tribunals, gendarmes and budgets, and I can whip the lot of them'.

'The devil!' said the painter. 'He'd make a splendid picture'.

'Tell me, you headsman's squire, you Widow's steward (that name, full of fearsome poetry, by which prisoners call the guillotine)', he added, turning to the chief of police, 'be a good lad, tell me if it's Fil-de-Soie that sold me out! I wouldn't want him to pay for another man's sins, that wouldn't be fair'.

Out of this whole episode we will concentrate only on one of its aspects, namely, how we ought to arrange the group of dumb-struck lodgers, gathered in Mme Vauquer's sitting-room and suddenly subjected to the fiery invectives of this pariah, cast out of 'respectable' society, thrust beyond the boundaries of the bourgeois order, which at the moment is personified by these petrified denizens of a gentlewoman's boarding house.

An analysis of this miniscule problem will furnish us with everything we need to say regarding the aspect of mise en scène that concerns us here.

At the time the discussion was prompted by a surprising solution, proposed by one of the students.

The triumphant moment of moral indictment was staged as follows:

He had Vautrin mounted on a table.

The lodgers were made to surround the table.

But just as his M. Vautrin—or Trompe-la-Mort—was about to pour out his fiery philippics over that rag-tag bunch, he was cut short by my question, addressed to the audience.

'Is such a mise en scène possible?'

I qualified the question: is it realistic?

After some debate over the question of whether Vautrin's climbing up onto a table was in fact plausible, everyone pretty much agreed that it was, given the flamboyant nature of his character, which moreover had been repressed for so long, along with a sufficiently sturdy table, etc., etc.

The storehouse of collective practical experience was thoroughly ransacked, whereupon it was resolved that there was nothing in such a spatial arrangement contrary to practical lived experience and common sense.

Matters stood far worse when I asked my second question: '

Are my pupils satisfied with this 'perfectly plausible' arrangement of characters?'

This elicited a great hubbub of complaints of every stripe, which, when reduced to a sort of common denominator, coalesced into something like a collective 'no'.

When I ventured to inquire about the cause of this dissatisfaction—evidently not a matter of plausibility—no coherent answer was forthcoming.

Then I suggested that my charges try a different tack.

Forget for a moment what the arrangement (proposed by our colleague at the board) is meant to represent and imagine a situation that would indeed agree with such an arrangement of characters.

At this—after a brief pause, necessary to dissociate the proposed spatial arrangement from the scene at hand—the answers tumbled out rather quickly.

'Revolutionaries gathered in a tavern on the eve of the French Revolution'.

Someone even proposed: 'Camille Desmoulins haranguing his confederates'.

'Choirmaster rehearsing a chorale', proposed a third.

'A preacher among his disciples'.

Etc., etc., along the same lines.

The only kind of 'reading' that no one suggested was a situation in any way resembling the assigned scene with M. Vautrin!

It would be natural to conclude that the proposed arrangement was in some way contrary to the Vautrin scene.

On the grounds of plausibility?

No—we have only just agreed that there was nothing implausible about such a mise en scène.

There must be another factor.

To be sure, the only remaining factor was composition.

Clearly the proposed arrangement did not suit the assignment compositionally.

Moreover, compositionally such an arrangement also communicated quite emphatically a certain 'something'—a 'something' that simply did not agree with any situation even remotely resembling that of M. Vautrin.

Actually, one could not help suspecting that it 'agreed' with something completely opposite to what had been intended in the Vautrin scene.

This suspicion quickly turned into conviction.

And the nature of the contradiction emerged especially distinctly also by virtue of the fact that both instances clearly shared a common element: someone is addressing a group.

And immediately we could see where the two scenes clashed. More precisely, in what sense the two scenes turned out to be opposites of one other.

It was in the nature of this 'someone's' relationship to the rest of the group.

All the situations that 'agreed' with the proposed arrangement—for all their superficial differences—were united in their treatment of this relationship.

In all of these instances (leader of a faction, orator, Desmoulins, choirmaster, preacher among disciples) we are dealing with a group of like-minded individuals, persons belonging together, members of the same circle.

And the one addressing them—flesh of their flesh and blood of their blood—is one of them.

Yes, he is the chief, the leader, the central figure, *primus inter pares*—but in every case he is of their circle—an insider.

Thus such a situation—in terms of the relationship of the individual with the group—is diametrically opposed to what is happening in Balzac's novel, where Vautrin is—first and foremost—an outsider, 'alien', 'outside their circle', 'cast out of their circle'—whereas the adored leader, the torch-bearer is invariably at its centre, just like a geometrical centre that unifies all, that holds all the points of a circumference in an indissoluble union.

Might it be possible, nevertheless, to stage this episode 'à la Desmoulins'?

Generally speaking—strange as it may sound—it is possible.

But, generally speaking, only as … a comedy.

Give Vautrin a clown's mallet, turn his fiery wig orange, and have this 'Bim-Bom' rain down obscenities—and the mallet's blows—upon the heads circling the table and sheepishly taking in his invectives—and you get a traditional comic scene à la Tabarin, Hanswurst, street farces.

The proposed mise en scène turns out to be satisfactory for this situation only if we want to give it a comic interpretation.

I.e., an interpretation that negates the very essence of this episode.

We might note in passing that comedy (and its irrational aspect) is grounded largely in 'negation'.

This becomes evident when we examine the theories of the comic put forth by the various schools of philosophy.

Such theories invariably contain the element of negation of whatever each particular philosopher considers as the inviolable fundamental principle.

For Kant the basis of comedy is the unexpected and the unpredictable.

Indeed, to an exponent of metaphysical predetermination and the immanence of all existence, what could be 'funnier' than an unexpected phenomenon, i.e., an event that escapes inviolable metaphysical predetermination?

For Bergson and his doctrine of vital impetus [*élan vital*] anything that opposes it and denies the cosmic creative spirit and its sole creative foundation—first and foremost, anything mechanical, i.e., produced by the industrial labour of generations of real people—will seem funny.

This principle applies also to the most popular definition of the comic as the 'alogical' in an era when 'logic' and 'reason' are taken as the alpha and the omega of the inviolability of existence.

And even in the 'senselessness' of comedy we hear the negation of the 'seemliness' and 'soundness'[10] of the physical standard of vitality, first and foremost, negated first by the comic, inadequately endowed human specimen,[11] and later by all manner of behaviour that deviates from the 'seemly' norms of reasonable conduct.

Presumably this is also the reason why the Devil assumes the comic role in Christian folklore and in mystery plays.

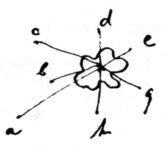

Figure 1: The mise en scène of Vautrin's capture in *Le Père Goriot*.

The Devil is comical in his efforts to oppose the Divine principle, in his denial of divine grace and the salvational function of the Deity, in his investment in sin, i.e., the negation of grace.

And when we recall that the most magnificent Devil in the whole of world literature—Mephistopheles—is dubbed 'the spirit of negation', then our hypothesis begins to sound rather persuasive!

One way or another, the mise en scène proposed by my student for the Vautrin episode turned out to be more suitable to a scene wholly contrary to it, as confirmed by the fact that it could be used to render the Vautrin episode comical, i.e., 'negate' it—to achieve an effect wholly opposite to the one we were looking for.

What shall we do to come up with a compositionally appropriate solution?

Clearly, we must stage the 'opposite' of our comrade's idea.

That is, in place of the proposed scheme that has Vautrin at the centre of the circle we will come up with a plan that puts him outside the circle, out of bounds, contraposed to the circle.

But ... these conditions we are setting for the correct solution, have we not stated them before?

When we were describing Vautrin's position vis-à-vis 'society' (personified here by Mme Vauquer's lodgers), did we not use the same handful of expressions?

Did we not say that Vautrin was 'cast out of this society', that he was 'thrust out of their circle', that he 'throws down a challenge' to this society (implying that they are separated, that there is a 'where from' and a 'where to' for such tossing of challenges), that Vautrin and society are opposed to one another?

That is exactly right—we had said all of those things!

But we spoke them in a different sense, in a different key.

Me-ta-pho-ri-cal-ly.

Now it turns out that they form the basis of the correct composition, i.e., of a mise en scène that reveals plastically the relational dynamic between the characters in the scene through their physical interactions, wholly and thoroughly transposing these 'metaphorical' descriptions into a system of concrete spatial interactions.

In spatial terms nothing has yet been fixed or specified.

Nothing except the basic principle, which must form the basis of any particular mise en scène of this scene.

However we may end up positioning Vautrin vis-à-vis 'society' in this episode, he may never be placed at the centre of their circle, but always outside, always in opposition.

That is, all positions of the sort *a, b, c, d*, etc. (see Figure 1), are permitted, whereas position x is not permitted.

Any one of the positions *a, b, c, d, e, f*, etc.—interchangeably, in alternation, sequentially or each one individually—invariably express in simple graphic terms the idea that we are faced with some sort of group and some individual who does not belong to the group (is cast out of the group)—an individual who is opposed or opposes himself to this group.

Moreover, the points *a*, *b*, *c*, *d*, etc. need not be located in the same plane.

They may be positioned above the group. Or even below.

In the first instance the idea of opposition will be supplemented with that of 'domination'.

In practical terms this may be done simply by furnishing Vautrin with a semicircle of a staircase leading up to the second storey.

And the image of a criminal 'towering' over 'society' will strengthen the message of the criminal depravity of this society.

The same staircase may just as easily turn downward.

Then the voice of Vautrin, coming as it were from the pit of the underworld concealed beneath polite society, will pour forth its terrifying invectives against those who are as guilty of iniquity as the world of vice swarming underfoot, which they have tried to contain in slums and ghettos.

The choice of position *a*, *b*, *c*, *d*, etc. will be dictated largely by the configuration of the acting space.

The choice of principal positions—whether the character is meant to proceed along their trajectory or pause at one or another at a climactic moment—or that of a single position, from which the whole of the monologue may be delivered, will depend in large part on the visual impact each position affords in light of the overall layout of the acting space.

We will discuss this in greater detail when we attempt to transpose this scene from the theatrical stage to the plane of the screen: from mise en scène to mise en cadre.

Naturally, the proscenium 'box' will impose here its own limitations, as well as advantages, as opposed to an open stage surrounded by the audience on all sides (which likewise has its own peculiar advantages and limitations).

The important thing is that in any circumstances the indicator of Vautrin's relationship to the lodgers will remain essentially unchanged, because this 'universal' spatial 'formula', in its most general form, embodies or communicates the principal dramatic, operative connection between these two opposing entities: the individual and the collective.[12]

At the same time, the 'formula' we have arrived at is not limited to the strictly graphic elements of the spatial mise en scène.

It radiates outward to all the other elements of composition.

If, for example, we consider the colour treatment of this scene—say, in its costume design—our 'formula' will render us the same service.

We would also try to express the same idea in terms of colour.

As far as plausibility is concerned, there are no limitations when it comes to costumes.

As long as the cuts and patterns are consistent with the fashion advertisements of the period, all is well.

Compositionally, however, the interpretive aspect of mise en scène puts a definite 'bridle' on this 'free-for-all' of costume design.

This 'bridle' is as liberating in one sense as it is restrictive in another.

Restrictive insofar as it must serve the main idea—liberating insofar as the creative imagination is free to satisfy the first requirement however it pleases.

In terms of colour our formula evidently yields two requirements.

First, that the colouration of various members of the group, regardless of the intensity of any one colour, must not undermine our perception of the group as a kind of tonal unity.

Second, that colour-wise Vautrin must be opposed to the group and in no way allowed to 'blend in'.

Of course, these 'requirements' are of the most basic, 'canonical' sort, but they will serve as the foundation even for such solutions as might seem wholly contrary to them.

As we will see below, these typically show up in highly developed examples of mise en scène, where they often furnish 'supplementary' colours, as it were, acting as the foil that allows the main idea to stand out all the more prominently.

The actual palette or segment of the spectrum assigned to the lodgers, which sets them apart from the individual—Vautrin—is in no way specified here, so that every individual imagination is perfectly free to come up with its own solution.

As for colour intensity—brighter colours are more likely to be reserved for the sharply delineated individual, i.e., Vautrin.

Darker, less distinct tones—situated, moreover, within a narrow range of the spectrum—are likely to be assigned to the group, accenting not just their uniformity, but also their 'herd mentality' at this point in the story.

A more inventive solution might introduce fluctuating colour intensity, linked to the fluctuations of dramatic tension.

The group's colours might pale in a kind of visual 'fading'— analogous to the signal fading familiar to any radio enthusiast.

This is easily accomplished by a continual rearrangement of the group, so that the more neutral and more uniform colours are brought into the foreground, or by a gradual desaturation of the lights, or simply by shifting the group towards a darker area of the stage.

In contrast, Vautrin would gradually 'brighten'.

Those inclined to 'demonise' this character, this 'fallen angel' of indomitable energy, directed—alas! (one recalls Murazov's laments over Chichikov's misdirected talents)—to evil rather than good ends, might infuse his monologue with sinister crimson hues.

As though a small flame—at first localised to a tuft of red hair on his wig—'swells' in the course of the monologue into a blazing fire.

This is easily accomplished in any number of ways: in the heat of passion the actor might tear off his frock coat, revealing a crimson vest underneath; his face might glow red as he approaches a burning fireplace; he might step into a slanted beam of the setting sun; finally, a devotee of naked scenic artifice might simply fix him with a red spot-light.

The list of such techniques and their applications in the history of theatre is literally inexhaustible.

Many years ago Ira Aldridge confounded his audiences when, in the last act of *Othello*, his face would suddenly grow ashen, only to recover momentarily its deep warm tones.

The technical trick behind this effect was that at the right moment Aldridge would bring a lantern to his face.

The wick of the lantern was loaded with salt (NaCl). As everyone knows from classroom physics, the flame of such a lantern (or Bunsen burner) would then absorb the entire red-orange-yellow segment of the colour spectrum: a face illumined by such light will lose its rich, 'warm' tones, becoming grey and ashen in appearance.

By skilfully manipulating a 'loaded' lantern one could easily lend one's face a ghostly pallor at a moment's notice.

Some time ago (about 1920) I wanted to use this device *en grande* for a production of *Macbeth*.

At the entrance of Banquo's ghost servants were to bring in similar sorts of lanterns, so that the faces at the table would suddenly assume a grave colouring.

It is interesting to note just how universal this pattern is: the emergence of a contrapuntal principle, its subsequent *fading* and its eventual re-emergence on a new level.

Take, for example, the problem of 'colour orchestration' just before the arrival of Giorgione, Titian, Tintoretto, and Paolo Veronese! Here is how Sheldon Cheney describes the progression, entirely consistent with what I have written concerning counterpoint in literature:

> Colour is the typical, the salient resource that is freshly capitalised and made to serve in unprecedented ways. No longer a mere addition to the painting, or a means of harmonising, it becomes a leading element in the plastic orchestration. But it is to be noted too—having been overlooked in a great many critical estimates—that in the matter of composition in space, of formal organisation, the Venetians push far ahead of the Florentines. After the Sienese decorative formalism died out, the school of Florence progressively lost the abstract values of structure and plastic richness of the early expression, dispersing the formal synthesis under the new concern for anatomical truth, light-and-shade reality, scientific perspective and general 'naturalism'. Florentine composition may be expert in the mechanical surface aspect, but it is increasingly lacking in the deeper three-dimensional, self-contained power of movement. Raphael already is plastically weak. With Andrea del Sarto and Guido Reni the abstract and contrapuntal values have disappeared.

The school of Titian and Tintoretto beautifully revives the pictorial compactness, the structural soundness, of painting. It goes on to unparalleled achievements in volume-space organisation. It makes painting a symphonic rather than a melodic art. It is from this source, moreover, that El Greco picks up the impulse to his superbly contrapuntal art, El Greco who is to preserve and utilise the abstract and mobile elements in painting, and to become—so masterly is he in this matter of plastic creation—the god of the twentieth-century moderns.[13]

One way or another, any kind of colour flux and degree of colour flux through this scene are perfectly permissible.

But the very nature of such expressive fluctuation of colour palette—towards brighter colours for Vautrin, the opposite for the group—always maintains the same principle of contrast of the multitude and the individual and vice versa.

In this case we would do well not to differentiate Vautrin from the group at the very outset—this would also emphasise the idea that he is ultimately flesh of the flesh, blood of the blood and a very 'product' of the same society, the same social order, which he later comes to denounce with such vehemence.

As for the idea of shifting colour (in step with developing action), let us keep it in mind: we will examine it later, when we speak of the colour dramaturgy of a film.

For the moment, let us turn our attention to another critical point, which follows directly from our discussion of colour in this episode.

I mean the degree to which the compositional 'formula' that we have 'derived' for this mise en scène ought to be made explicit in a real production.

Let us imagine this scene on the actual stage.

Clearly, individual, concrete solutions based on our 'formula' may, at one end of the spectrum, retain and even emphasise its graphic schema, veil it to the point where it is unobtrusive and barely detectable, or practically discard it altogether.

Roughly speaking, at one extreme our mise en scène will be reduced to a precise geometrical figure.

At the other we would lose all traces of this schema in the naturalistic chaos of the characters' moving about the stage.

Between these extremes we can find an instance where the schema is strictly adhered to in plastic terms, but in such a way that it passes without notice, that it is not made explicit, but rather enters into our overall perception of the scene without drawing attention to itself.

The first 'extreme' solution will render our scene maximally 'expressive' in compositional terms: people arranged in a geometrically precise circular formation symbolising the 'social circle', and the cast-out individual dashing about outside this circle: formula laid bare in the action.

From the naturalistic perspective, i.e., as a reflection of how things are in real life, this is, of course, sheer nonsense.

Stylistically, this is the kind of 'convention' that may be found in the most excessively conventional specimens of conventional mise en scène.

The other extreme: disjointed, no longer unified fragments of a circle that tell us nothing of their cohesion and unity; a 'unit' freely circulating among them, neither 'with them' nor 'against them'. Here we have typical naturalistic 'blocking' of actors, and essentially a total denial of the self-contained expressive quality of mise en scène, whose far from arbitrary 'footprint' is meant to express plastically—

in the most general sense—on par with the actors' performance, the very same idea, the very same motif, the very same content that suffuses the scene as a whole.

Finally, a solution that lies between the two extremes.

Not a 'golden mean'—which implies a counterbalancing interference of 'extremes'—but a vital, dynamic synthesis of marked opposites.

The 'circle' is not perceived but intuited.

The opposition is never made explicit, but is present in all things.

The formless naturalism of one extreme amended by the rigorous order of a graphically expressed idea of the other.

The profligacy of naturalistic detail reined in by a rigorous inscription of plastic abstraction expressing an idea.

The general never loses its connection to the particular.

The particular appears in concert with the general.

What more could we ask of the principles of realistic mise en scène?!

And we can clearly see how easily and imperceptibly one may slip from this essentially realistic composition towards one extreme, naturalistic, or the other, conventional and 'formalist'.

It's just like declaiming verse.

A little too much emphasis on the period of the rhythm, and the recitation turns into a lifeless mechanical drone.

A touch too slack on rhythmic delivery, and the distinct cadence of verse disintegrates into the baffling formlessness of semi-prose.

A little too much emphasis on the circle, and the mise en scène starts to lean towards ballet and conventional theatre.

A bit too careless with the geometric figure, and the clear, distinct, meaningful mise en scène is sucked into the swamp of formless naturalism...

[Mise en cadre and montage]

While we are on the subject of the composition of details, let us examine yet another example and 'confess' what (and when and where) had determined the choice and order of certain details.

(I doubt anyone would ever have guessed it!)

In the treatment [for *The Great Fergana Canal*][14] we read:

'The poet Tokhtasyn sings of the olden days.

This is his song . . .'—followed by an account of the siege of Urgench.

In the screenplay we already find:

'The poet Tokhtasyn, looking out onto the desert . . . sings of the ancient city of Urgench . . .

A boundless desert spreads before Tokhtasyn . . .'

And the wondrous reappearance of the city, of the past magically conjured up by Tokhtasyn's song, was done—albeit correctly—in the simplest, technically most straightforward fashion.

'Boundless desert sands . . .

As the song begins, we dissolve to a wide view of a prosperous ancient city . . .', etc.

Of course, there is a touch of magic even in the dissolve. But this is magic of the dime-store variety, whereas we would like to see much more of its oriental dream-like quality.

Now, where was it that I had already come up against this problem of magic in a script transposed from a literary passage?

Got it! Many years ago this was. One or two, to be exact. At the Film Institute, when I had to correct a student's clumsy, insensitive rendering of a passage from the first chapter of *Eugene Onegin*.

Here is the passage:

> The house is full, the boxes beaming,
> the orchestra is all a-buzz;
> the gallery erupts, impatient,
> the curtain rustles in its flight.
> Magnificent, semi-translucent,
> obedient to the magic archet,
> within a throng of nymphs entwined,
> there stands Istomina; she is... *etc.*

For the moment let us ignore the first few lines, though these too are full of remarkably curious instances of visual writing,[15] and proceed directly to the main event—the 'delivery' of Istomina.

The shot breakdown is perfectly obvious:

1. Magnificent,

2. Semi-translucent,

3. Obedient to the magic archet,

4. Within a throng of nymphs entwined,

5. There stands Istomina,

6. She is... *etc.*

In passing let us note the remarkable manner in which the text actually sets the 'footage'—i.e., the respective length of each shot— by way of syllable count. If we take a single verse as the unit of footage, then shots nos. 1 and 2 will be half-length, nos. 3 and 4 will be full-length, no. 5 will be two-thirds-length and no. 6 one-third, with the obligatory pause in between, as though the audience has momentarily frozen in awe before Istomina. Well, there is no end of analysis here! The built-in tempo 'cues' alone in shots 3 and 4—

virtually identical in their outward duration—are priceless. The syllabic rhythm in the first verse evokes the bowing of the violin, while in the next it mimics the flowing movements of the nymphs!

For the moment, however, we are interested only in the visual contents of these six consecutive shots, such as might capture the inner plastic charm of their succession as Pushkin conceived it. Or, at any rate, approximate it as closely as possible.

—No. 1. 'Magnificent'. After the soaring curtain (which rustles!) this is the initial vision of all that sparkles. The first sensation of radiance. Just what the radiant object might be is still unclear. This is almost 'radiance *per se*'.

In technical terms, a 'monocle' lens (which produces a soft-focus image, blurred at the edges) trained on the glimmering bodices. It may be that a soft-focus lens, which transforms every glint into a burst of sparkling stars, would work even better. This will probably be a medium shot, to allow for a gradual and fluid transition to a wide shot in no. 3. The latter clearly calls for a wide view, since there we seem to get some of the orchestra in the foreground, similar to how Degas liked to place his violinists.

—No. 2. 'Semi-translucent'. The motif of translucence is approached similarly to that of radiance in the preceding shot. These are doubtless complementary. This shot is a little longer (by one syllable). This is perfectly natural: it must be a little wider (tending towards the third) and therefore also a little longer. The same blurred view, trained on everything airy and light: all that is gas and gossamer. If the first shot is a static group, alive only in its radiance, here it is perhaps fluttering (ethereal, 'semi-translucent').

—No. 3. 'Obedient to the magic archet'. We now have the entire stage—in soft-focus—in the background. In the foreground—

in sharp focus—is the silhouette of a violin and the movement of the bow. The stage is revealed step by step. In shots 1 and 2 it opens up completely. But it is still not fully exposed. It still lacks focus. Both the stage and Istomina herself are gradually exposed, while at the same time they remain obscured through a variety of visual contrivances.

—No. 4. 'Within a throng of nymphs entwined'. A new way of veiling what has nearly emerged from this tangle of radiance and translucence. Before Istomina—between Istomina and the camera—stream the encircling nymphs, a dynamic equivalent of the verbal cue 'entwined'. This is a new kind of 'soft-focus'—a 'blurred foreground', an effect of the moving figures passing in front of the field of focus, and so with every passing nymph casting a kind of semi-translucent veil over the central figure of Istomina. (The framing is presumably somewhere between shots 1 and 2.)

—No. 5. 'There stands Istomina'. The successive 'veils' of various kinds of blurring and elision (shots 1 and 2) now fall away. At last her figure emerges, and just as the last traces of occlusion slip out of the frame, we go to:

—No. 6. 'She is'—a close-up of Istomina.

This solution, to my mind, comes most closely and most economically to communicating visually the full complex of sensations that one experiences in reading this particular passage from *Onegin*.

And here we have captured something more than the mere rhythm of the visual flow of the original sequence of images.

Our solution captures and contains a great deal more. These four lines of Pushkin's are strictly 'documentary'—every detail is concrete and representable (radiant; semi-translucent; moving to the rhythm of the violin bow[16]; encircled, etc.).

There is only one detail that is not representable—one attribute, to be exact: the 'magical' quality of the bow. There is nothing we can do to the bow visually that could communicate this quality.

But if we shift our attention from a single image to the whole complex of images—or rather to the process of their succession—we will see that the very order of successive shots may well capture the essence of that sole instance of figurative speech that Pushkin has allowed himself in this passage.

Indeed, the plastic trajectory of the successive shots is such that together they create a sense of magic, or evoke the idea of magic, as out of an obscure, radiant, semi-ethereal half-being of glimmering dots and vague outlines, the gliding bow conjures into existence the figure of Istomina.

In this way the figurative quality 'magical'—impossible to represent in a single shot—emerges in its full force in the succession of shots, flowing one after the other.

That is, the 'magical' quality is captured in the montage. All we need is the correct order of succession and the elements capable of coming together to evoke the requisite sensation of 'magical quality'.

[The mise en geste of colour]

The autonomy of a 'wash' of colour, independent of the form or type of object.

Surprising as it may be, this too is copied directly from human behaviour.

And not just any behaviour, but expressive behaviour—acutely emotionally... tinged!

For a man in various emotional states finds himself variously coloured, and not figuratively either! He literally takes on different colours.

Embarrassed, he blushes.

Chokes up and turns blue.

He's green with envy.

White with rage.

Pink with pleasure.

At last he turns—not momentarily, as before, but for a good stretch—canary yellow in a fit of bile.

As we all know, an especially unpleasant abrupt emotional reaction triggers an outpouring of bile in the organism.

The ebb and flow of blood, spurred on by various other emotions, dictate the changing 'palette' of a face.

These colourful manifestations are so characteristic that often they are regarded as mere symptoms.

They may reveal a man's momentary emotional state (at such-and-such news he turned pale, meaning...), his long-term state of health (a patient's unwholesome colour, turning to a healthy complexion as he improves; dark circles under the eyes after a night of excesses, etc.), occasionally a permanent disposition (inasmuch as we can speak of permanence within the narrow boundaries of our brief existence: a drunkard's purple mug; a hemorrhoidal complexion).

Every colour in this sense is a symptom, it 'signifies' something—i.e., it serves as a sign of a momentary, extended or permanent (characteristic) state—either emotional (affective) or narrowly physiological (a face suddenly grown pale vs. one that has become pale as a result of chronic malnourishment).

As we all know, at the early stages of mental development signs, appearances, characteristic markings do not simply reveal the essence of a thing, they *are* the essence: one need only reproduce the symptom or the attribute by a 'magic' operation to conjure up the whole of the essence. Health, for example, is associated with a

pinkish hue of the face: to make a man healthy we need only colour his face pink—and he will be made healthy.

This is precisely the principle behind war paint.

The inscribed figures—figural representations reduced to a couple of strokes and smudges (in accordance with the principle of *pars pro toto*), as well as the colours themselves (also per *pars pro toto*)—endow the warrior with attributes associated with such colours and such objects.

The magical stage is then suppressed for a very long time. But just as the magic of today's Kio[17] is founded on nothing more than optical illusion, so too vestiges of various magical techniques of old have migrated into the realm of deception and 'misdirection'.[18]

The new development here is that we no longer believe that paint will produce a real effect, but we are sure that the sham effect will suffice to fool our 'neighbour'.

A young girl painting her lips knows full well that she will not thereby attain the kind of vigorous health typically associated with 'red, luscious lips', but she is quite sure that the counterfeit will nevertheless induce in her suitor the same strictly physiological response—contrary to the dictates of reason, which is hardly fooled by such crude 'touching-up' of reality—as if he beheld a creature truly glowing with health, as such intense colouring of the lips would indicate. After all, this too is 'magic': he is 'bewitched'!

And wherever we find such unwritten but strictly codified correlation of form and colour—principally attesting biological advantages—we will also inevitably discover a highly elaborated arsenal of subterfuges. Here belongs the corset of bygone days, designed not to mould a slim waistline, but to give a normal waist the sought-after appearance; the bustle; the brassiere; the shoulder

pad of a man's jacket; the high heel, compelling even the most rigid frame to assume an alluring curvature, 'showcasing' the bust and the rump, seemingly shaped so by nature, but in reality mounted on a French heel, etc., etc.

Coming back to colour, we must acknowledge that emotional response to this or that segment of the colour spectrum is evolved in accordance with centuries of accumulated experience, practically transformed into inherited reflexes that, nevertheless, will nearly always be found to have a perfectly 'rational' biological motivation. Recall once again the colouring associated with vigorous health and anemia, respectively.

High hemoglobin content is of such vital importance to us that not only does its attendant complexion become closely associated with an impression of 'health', but the colour itself, abstracted from the face, continues to rouse positive, life-affirming associations.

Moreover, even its verbal counterpart quickly takes on a figurative dimension, so that we may speak perfectly naturally of Shakespeare's 'full-blooded' depiction of characters or of 'anemic' canvases in the age of decadence.

It is, therefore, perfectly clear that colours carry no immanent or intrinsic emotional impulse, but are able to trigger an emotional response on account of their long-time associative (or reflective, if you will) connection to certain natural phenomena fundamentally linked to ideas of vitality or decay, or to social phenomena closely associated with specific colours (e.g., the overwhelmingly positive or acutely antagonistic 'class' response to the scarlet banners of a May Day rally, etc.).

(Elsewhere we shall give a more detailed account of environmental conditions vis-à-vis 'warm' and 'cold' tones.)

The case of brown, for example, is most curious in this regard.

For it fits into neither the 'cheerful, warm' nor the 'cold' segments of the colour spectrum.

And here we can see perfectly clearly to what extent response is something relative, dependent on circumstance and context.

So, a browned rotting apple, for all the velvety warmth of its colouring, is hardly alluring.

On the other hand the bronze of a tan (ranging from nearly copper to practically blue), associated with the wholesome sensation of a body suffused with solar energy, is emotionally attractive (everyone is familiar with the unsavoury impression of the 'unhealthy' pallor of untanned flesh among bronzed bodies on a beach).

And even here, at the most basic level of colouration, we find a 'subterfuge'—a 'forgery' of tonal symptoms, signalling superior physical attributes first and foremost.

There are great fortunes to be made in this trade!

Companies flooding beachside districts with their shrill advertisements—'Easy-2-Tan'—and selling a brownish liquid that gives a complete illusion of a tan when rubbed into the skin—are raking in big money!

This sort of subterfuge is not limited to colour. It even goes as far as smell. I once had the pleasure of reading an American advertisement for a special men's fragrance, formulated to heighten the impression of its wearer's 'masculinity' by imparting to him a 'barely detectable' melee of scents, vaguely suggestive of choice tobacco brands, the tanned hide of horse saddles and leather gloves, and even horse stables!

Consequently, we can be sure that the continual flux of tonal values upon the surface of an object, whose form meanwhile remains unchanged, is rooted in the very deepest layers of human nature and is most closely associated with the emotional and

physiological processes unfolding within us and 'lending emotional colouring' to the principal expressive outlet of our feelings and passions—the face.

As a result we have evolved, perfectly spontaneously, of course, something like a universal code for interpreting characteristic displays of colour, deeply rooted in man's physical and affective reality.

To be sure, 'universal code' is a highly relative designation, limited to a shared social background and subject moreover to certain 'racial' correctives, inasmuch as race determines complexion.

So, a yellowish tinge of the face in our society and among the Mongols, naturally endowed with a citrine skin tone, would obviously occasion two radically different interpretations.

The play of changing colours on the face of a Negro or a bronze-coloured Mexican Indio or a red-skinned American Indian would be of a very different variety than that of their paleface brethren of European descent.

This caveat to 'universality' is unavoidable, of course.

To say nothing of the perpetual change of colour in natural phenomena, occurring every minute throughout the day under incessantly changing lighting conditions: to cover this adequately one would need to quote from many volumes written on the subject and expound all the creeds and experiments of the Impressionists.

The objective fluctuation of colour in nature has been studied exhaustively.

We may wish to note only that the interest and attention generally displayed towards this phenomenon remains so acute, it would seem, precisely because the objective tonal flux occurring in natural phenomena seems to mimic our own subjective internal processes, as we have described them above.

This is reflected in language.

'Windows flare up under the rays of a setting sun'.
'Objects blushed at the first rays of morning light'.
'The skies grew red'.
'The yellowing fields of rye'.
'The meadows burst with green'.
'The distant blue of the sea'.

This is more commonly said than 'the setting sun gilded' or 'lit the fires' of the windowpanes.

(If not *more* commonly than certainly not *less* so!)

In reality this transfers onto natural phenomena one's own propensity to change colour, though we know full well that these phenomena are the results of various external sources' shedding their light emissions on particular objects, thereby changing their tonal appearance.

As we can see, among the relics of animism—which survives in our anthropomorphising of natural phenomena—we have retained this peculiar feature of observed human behaviour.

In this respect the animal kingdom is considerably inferior to humankind.

At best one gets blood-shot eyes.

A turkey's head.

With the exception of the chameleon's ability to assume—by way of a complex transition from the objective colouring of its surroundings to its subjective recreation—the colouring of whatever environment it happens to inhabit.

Here we are witness to a process that reproduces—in 'real-time', in a matter of seconds—the centuries-long evolution of protective colouration.

Interestingly, the development of man's own protective colouration, his war camouflage—the famed 'khaki'—likewise (for all his

brainpower!) took several millennia: it was only in the early twen-
tieth century that we were finally able to get rid of the last vestiges
of primitively intimidating, aggressively coloured soldier's uniforms
and replace them with the far more rational cover of invisibility by
blending in with our surroundings.[19]

The extent to which this self-colouration is instinctively deeply
linked to our general ideas of colour is attested also by the fact that
in cinema's earliest experiments with colour (well before anyone
addressed himself to the question systematically!) this same feature
surfaces in the very first colour tricks.

In comedy the palm of victory (or, at the very least, one of
its branches) belongs to the now 'ancient' *La Cucaracha* [Lloyd
Corrigan, 1934] in the live-action category and to Disney's *Three
Little Pigs* (1932) in animation.

Disney imitations and self-imitations have literally done the
trick to death! (Though it was successfully revived by the blushing
skunk in *Bambi* [1942]).

As for its use in a dramatic context—with the device similarly
laid bare—I believe I was the first person to use it this way.

And similarly—this was my very first colour experiment (the
colour sequence in the never-released Part II of *Ivan the Terrible*).

In all three instances the 'colour trick' is one and the same: a
character changes the colour of his face.

The colour changes right before our eyes.

A new colour 'comes over' his face.

One colour, pink (in the first two instances), is physically re-
placed by another, crimson.

The body and face of a pig go from pink to crimson, as the latter
colour gradually fills in the space circumscribed by the character's
physical contour. (This represents embarrassment.)

Similarly, a wash of crimson gradually 'moves up' the face of Paul Porcasi, the impresario in *La Cucaracha*, who has just eaten a very spicy salad (blood rushing to his head in a fit of rage!).

In both instances the comic effect[20] is achieved by sticking to the old formula of 'concretising the metaphor': 'colour rose to his face'—let's literally flood his face with colour.

It had not occurred to anyone to risk the same technique in a dramatic context—except me. (Winter of 1945.)

Naturally, this was only possible in circumstances as emotionally wrought (not to say over-wrought) as the climax of the 'Feast in Alexandrova Sloboda' scene, which is precisely where we attempted it.

(Just as a non-comic effect of the concretised metaphor 'stones roaring with rage'—*Potemkin*'s springing lions—could only be attained at the highest pitch of emotional distress induced in the spectator by the whole of the preceding scene on the Odessa steps.)

Unlike the first two instances, where characters 'turn red', my character 'turns blue'.

Oddly enough, the choice of colour or even the choice of technique was in no way a response to or a polemic with these two 'precursors'—they were the farthest things from my mind.

In my case the idea came directly from past experience.

Sometimes it is interesting to trace the actual history of this or that technique or 'number' that suddenly bursts on the scene—i.e., produces an unexpectedly powerful effect—as a sort of mysterious 'revelation'. (In my article 'The Twelve Apostles' I describe the history of several such discoveries in *Potemkin*.)

The history of the 'blue close-up' of Prince Staritsky (played by Pavel Kadochnikov) is as follows.

In 1941, when I wrote the screenplay for *Ivan the Terrible*, there were no prospects of filming in colour.

The Tsar's story was therefore conceived in black and white.

By 1945 we did have that option.

I became a cinematographic colour convert when I saw the red carpets in the colour newsreels of the Potsdam Conference.

We also got film (three-colour).

By that time I had already shot all the scenes of Part II with the exception of Ivan's feast in Alexandrova Sloboda.

It was the only scene in the whole two-thirds of the trilogy (I had always pictured the film in three parts), where colour might have actually worked organically.

Not because a feast affords a pretext for an 'explosion' of colour. But because in this episode colour could have a purely dramaturgical function.

This is certainly not the case everywhere and every time, because colour is only appropriate where it is dramatically and dramaturgically necessary or potentially necessary, just as a meaningful, organic combination of visual elements and music is only possible in compositions of a particular musical-dramatic order.[21]

In this instance studio management proved sufficiently sensitive to see things my way. I was permitted to film the scene in colour.

This presented a certain stylistic difficulty vis-à-vis the film as a whole.

This difficulty seemed especially to trouble some of my more spirited colleagues—but not me, since to my mind it was not a difficulty at all, but rather the sort of challenge that, when handled properly, may well yield a surprising discovery, an unscripted compositional solution.

And that is precisely what happened.

What was this 'alleged' difficulty, or rather fruitful circumstance?

As it happens, the 'Feast' was not the 'crowning', final scene of the film, but the penultimate one.

What is worse, the final scene had already been filmed.

And it had been filmed, along with the rest of the material, in black and white.

This was a rather powerful scene: Prince Vladimir walks through the cathedral, where he is struck down by Volynets with a knife blow intended for Ivan himself.

Consequently, the film was 'doomed'—after an 'orgy' of colour— to revert once more to the black-and-white (actually overwhelmingly black) palette...

This 'impending doom' hardly troubled me.

On the contrary!

It suited me in every respect.

First and foremost on account of colour—or rather: the dramaturgical possibilities of colour.

As it happens, the inner colour dynamic of the 'Feast' episode demanded a kind of 'dying away' of colour towards the end, so that colour is gradually overwhelmed by darkness: a motif that is first introduced when a monk's black habit is draped over an *oprichnik*'s golden robe (as the bell tolls, announcing matins, and Ivan calls an end to 'accursed fornication'), and gradually expands over the entire scene.

The following scene, dominated by black, in no way conflicts with what came before; on the contrary, it continues—organically and dramaturgically—the idea introduced in the feast episode.

It is interesting to note that the idea of darkness swallowing up a golden robe was initially conceived in black and white: it is perfectly within the scope of the black-and-white palette, where the contrast of the light robe and black gown is further accented by their re-

spective textures—the brilliance of gold embroidery vs. the dullness of the velvet habit absorbing all light.

In the overall order of scenes leading up to the murder of Prince Vladimir this gave us a presentiment of his demise, evoked for the moment solely through the conflict of colours: black overwhelming white.

The only remaining thing was to 'cushion' somehow the abrupt change from full colour to full black (black and white).

As luck would have it, between the feast and the murder there was a small interstitial scene—just three or four shots long, also already filmed in black and white—wherein Vladimir walks through the snowbound courtyard towards the cathedral.

I decided to immerse this connecting link into some sort of connecting colour principle.

Is there something in between polychromatic and monochromatic, i.e., black-and-white photography?

Of course there is—monochromatic tinting.

I chose to use this sort of monochromatic tinting for the transitional shots—from the full-colour palette of the feast scene to the predominantly black palette of the cathedral scene. We settled on a blue tint.

Its colour continued the polychromatic line of the preceding scene, while its monochrome quality prepared the transition to the monochromatic (moreover completely colourless) scene that followed.

To make the transition from the feast to the courtyard as painless as possible, the final images of the first were limited to the black and blue palette (blue wall beside the small doorway through which Vladimir will exit).

Black and blue (blue snow and the blue-black habits) continue the colour motif, suggesting moreover a snowbound court-

yard bathed in pre-dawn blue after the fireworks of the preceding orgy.[22]

Thus the main 'obstacle' was 'removed'. Another obstacle, albeit minor, remained.

In the course of the scene, as Vladimir nears the door through which he will lead the procession of guardsmen into the cathedral, the prince 'comes out of his daze' (see script).

Suddenly he realises that he and not Ivan, whose robes he wears, will be struck down by the murderous knife.

He tries to find a way out.

Refuses to go forward.

Would speak with Ivan.

But this only confirms Ivan's suspicions that something foul is afoot: until this point he merely suspected a conspiracy, but now, seeing Vladimir suddenly sober and reluctant to go out, he is convinced that his suspicions are well-founded.

Vladimir's fate is sealed.

He will walk into the trap laid for the Tsar.

Just what the trap is Ivan does not know.

But he cuts off Vladimir's escape route.

He won't let him utter a word.

He bows to him from the waist.

Invites everyone to do the same.

Beckons the prince to lead them to the cathedral.

And says to Vladimir, decked out in royal garb:

'It is not fitting for a Tsar to retreat. The Tsar always leads the way…'

The creative team (present author included) considered it essential to indicate at this point what was in store for Vladimir.

The condition of a man who knows what awaits him (death), whose every step brings him closer to death, lying in wait at every

turn—this seemed to us emotionally most appropriate at this point.

Therefore it was not enough to have Vladimir simply 'sober up' before the doorway.

We had to show that as his mind clears he realises that a murderer is waiting for him in the cathedral.

(Vladimir's 'feeble-mindedness' renders him incapable of finding a way out of his predicament; knowing what lies ahead, he—so accustomed to be ruled by others—continues his march towards the dark, deadly cathedral with nearly mechanical determination, but also with pronounced terror in the face of sure death.)

Therefore it is very important to link the 'deadliness' of the cathedral with the moment of the prince's sobering up.

Of course, this is done easily enough: by cutting in a shot of the murderer's slipping behind a pillar of the nave, past which Vladimir will presently lead the procession of the royal guard. In this context such a shot will be read as parallel action (meanwhile, a murderer penetrates into the cathedral ...) and, at the same time, as Vladimir's vision of his impending doom.

But...

The shot of the murderer's progress has already been filmed.

And it was filmed in black and white.

And now it will be inserted right in the middle of a rather close colour shot of Vladimir—with his fair locks and golden finery, moreover lit by the red glow of a candle, trembling in his hand and held right up to his face peering into the void.

Next to such a 'warm' palette, the shot of Volynets' progress through the cathedral is bound to look drab and grey.

Also it would disrupt the colour progression of the whole scene...

Naturally, the shot inside the cathedral would be tinted with the same blue tint we used outside in the courtyard.

But such a starkly blue image, cut into the yellow-orange close-up of Vladimir's face, would fall perfectly flat.

It would look about as 'organic' as a black eye—the mark of a fist punch—on a ruddy face.

What to do?

And that's when the 'trick' suddenly came to us all by itself.

For the blue shot to 'fit' organically in the middle of the yellow-orange close-up, the first half of the latter must at some point go blue.

The blue interior of the cathedral would then 'cut' quite painlessly with such a 'discoloured' image.

We would then 'go out' of the blue shot in the exact same way: the returning close-up, blue at the outset, would gradually revert to its normal yellow-orange colouring.

Formally everything seems to be in order.

And what about substantively?

Substantively too!

Because the 'swell' of blue, like a musical passage, would echo the wave of terror that washes over (!) the prince, spill out into a concrete manifestation of this terror (in the same colour key!) and retreat to find Vladimir emerging (!) from his stupor, from the grip of terror.

That's just what we set out to do.

And it's just what we did.

And the curious part is that everyone felt that it came out natural, organic, just right.

Realistically (not to say naturalistically!) convincing.

The basic phenomenon of human behaviour—'his colour changed'—in the case of Prince Vladimir only slightly exaggerated—is so deeply ingrained in human nature that it remains organically convincing despite the exaggeration.

I have dwelt at such length on these individual cases because I believe this phenomenon reveals to a great extent the psychological basis of our emotional response to such colouring as people or objects may 'assume' with the help of coloured lights, reflections or simply paint and make-up.

Especially to fluctuations of colouring.

Attaining increasingly subtle psychological effects as the primitively comic or dramatic 'novelty' one-colour 'wash' gives way to orchestrations of colour palettes, changing lights, reflexes and reflections, interacting moreover with the overall colour design of scenery and surroundings.

An individual or *in extenso* an object 'flooded' with colour is understood reflexively, at some primitive level, to 'produce' this colour internally, from within.

The little skunk Flower (in *Bambi*) that turns bright red at the bidding of Walt Disney is understood to be blushing.

Red highlights on the face are instantly associated with blood rushing to the face.

Coupled with an angry look it will be read as rage.

With confusion—as embarrassment.

Similarly, blue highlights (in Vladimir's case) are instantly associated with consternation and 'bated breath', as constricted blood vessels beneath the skin turn blue, while Vladimir's terrified expression coupled with this lighting is read as 'mortal' terror (the blue face of a corpse, of a drowning victim).

Both the 'red face' and the 'blue face', induced by an external light source, are automatically readdressed to the realm of primitive emotional response, manifesting itself in 'outward' colouration.

This outward colouring is read as an indicator of a corresponding emotional state, as the emotion itself, as the character's emotional

content, prompting the spectator's own emotional state to change in accordance with these 'alleged' emotions.

Be it 'in unison' or 'in opposition', 'commiseration' or merely 'acknowledgment'—i.e., depending on the spectator's position (chosen or imposed) vis-à-vis the character: identifying with him (maximum emotional effect), empathising, sympathising, merely agreeing with him or, on the contrary, opposing him, raging at his triumphs and glorying in his defeats, all the way to the indifferent 'acknowledgement' of changes in the character's emotional state, whenever there are no compelling reasons 'for' or 'against' him.

Consistent with the long outdated vestiges of animism, whereby man's attributes and faculties are extended to inanimate nature, landscape, plants and objects, the colouring of objects, whether by light or pigment, likewise lends an emotional aspect—by turns 'merry', 'sinister', 'sombre', 'cheerful'—to such phenomena as the 'cheerful' pattern of the wallpaper, the 'sinister' crimson hues of a rose bouquet or the 'innocent' blues of forget-me-nots, etc., etc.

Over time we amass a sort of clavichord of correspondences between colours and 'moods' or 'emotions' as relative and conventional as what we have in music.

Colours coalesce into chords, dissonances, mutually reinforcing or attenuating colour scales.

Tones.

It is not simply the painterly values that interest us here, but dramatic tonal values, i.e., considered principally vis-à-vis the emotionally expressive resonances they are able to elicit.

We have traced the origins of these resonances along one 'flank', as it were—following the subjective line.

As we have seen, the affective quality in this case takes its origin in the purely personal and radiates outward, as it were, projecting itself onto the surrounding objects.

But that is only half the story.

It is met with a counter-current: the entire system of objective correlations between colour and natural phenomena, as they occur outside of us in nature.

Here once again we encounter similar connections between colour markers and concrete phenomena of a different order.

Similarly primal and physiological at the very bottom of the pyramid of colour-association and colour-effect.

The colour red is associated with the sensation of warmth given off by fire, by 'red-hot' iron.

Orange—with the warmth of the sun.

Blue—with the cool of the shade, wherein we can now detect the reflex of the sky. Etc., etc.

Moreover, nature has 'contrived' it all in such a way that our inner, subjective experience and this one, derived from objective circumstances, are in accord when it comes to their most fundamental, most general distinctions. (As in the 'mainline' division of the colour spectrum into the warm, life-affirming part and the cool, deficient part.)

The most important conclusion to be drawn from these admittedly cursory observations turns out, nevertheless, to be absolutely critical.

The idea is that even in nature no object may be said to possess a 'fixed' colour: the colouring of an object is labile, mutable, unstable.

That of the human face is, moreover, associated with the emotional and physiological aspects of human nature, and is *in extenso* similarly identified in other natural phenomena.

In painting the Impressionists were the first to recognise and assert this principle.

Its practical implications for cinema are enormous.

It posits the flow of colour as a free and independent element, flowing through shapes and over surfaces of objects of representa-

tion that fill the film frame, which reflects objects set before the camera.

The colour track, combining with image sequences in accordance with its peculiar laws of expressive counterpoint, may flow through the image track no differently than music, which combines with it contrapuntally to form a compositional (expressive) unity, quite unlike the sort of 'unity' that exists between a boot and its characteristic creak.

We have already noted elsewhere that the first step towards an audio-visual art was taken when naturalistic synchrony was superseded by a synchrony imposed by the will of the artist.

When the creak of a boot was joined not to an image of the boot, but to that of a face, anxiously awaiting the boot's arrival.

Similarly, armed with the magic power of montage, silent cinema began its transformation into an expressive art at the moment when the creative will of the artist forced 'time out of joint', i.e., dismantled the natural order of things, henceforth imposing by the power of montage its own order of impressions and their relative duration upon naturalistic phenomena.

Nor is this anarchy for anarchy's sake.

But re-creation of phenomena for the sake of expressing my personal attitude towards those phenomena.

An attitude dictated by my worldview, my outlook on the world and its phenomena.

By that singular vision which by a wilful arrangement of material can communicate my idea in a manner that is acceptable to me.

Thus both montage and audio-visual counterpoint are grounded in the same principle: disjunction of existing associations—the passively existing associations of the order of things—for the sake

of establishing new associations through new combinations, new juxtapositions.

Both are directed towards the most striking realisation of my idea, my perception of the world, my sense of the world, my world-view—in a fragment of the world, a fragment of reality that is set before me.

Disjunction.

Disjunction as the initial phase in the recognition of that process, which must culminate in a qualitatively new synthesis of meaningful transformation and re-creation, communicating my idea, my thought, my attitude towards phenomena.

The need for disjunction may be seen just as readily here, in our discussion of composition as such.

Of all the instances of 'disjunction', at first glance it appears the most remote and complex, the least immediately accessible.

The cosmic passive correlation of objects inside a 'master' shot breaks down (relatively) easily into a succession of discrete shots.

All we have to do is track with sufficient diligence our attention's progress from object to object, the time it spends with each particular object, the 'frame' it imposes each time (to the exclusion of everything around a given object). This itinerary through the objects of attention will be different for every spectator.

The same is true of duration.

Moreover, for one and the same person both the itinerary and the duration will be different in different circumstances.

Especially so, if he has some personal interest in the matter at hand.

And they will differ drastically as soon as progression, duration and intensity of attention become subjected to the dictates of pur-

poseful demonstration, aimed at pointing up connections between elements of a phenomenon as it is construed by the 'author'.

So, in a battle scene, deliberately guided attention may linger on images of casualties or on feats of heroism, and any one 'take' on a subject will be a product of ruptured natural correlations of elements which comprise that subject.

So that a handful of corpses, for example, may be transformed through repetition and constantly shifting camera angles to achieve a far more powerful impression than we might with a general view of the battlefield strewn with hundreds of bodies. Alternately, the element of death may be completely removed by concentrating attention on the glory of a heroic act.

This phenomenon is all the more apparent in the audio-visual context, where sound and image are, by technological necessity, recorded onto separate strips of film and tape. A technological necessity that permits the artist to combine depicted events—freely, arbitrarily, unconstrained by the 'order of things'—with whatever sound he requires.

Teutonic hordes, soundly defeated by the Russian army, are sinking through the ice.

You are perfectly free to add a soundtrack that either laments the tragedy of the defeated or glories in the triumph of the victors.

(Your patriotic feeling will invariably suggest to you which way to direct the composer's art!)

Finally, you can use the soundtrack to evoke the entire course of the struggle, just as its finale is playing out before our eyes.

Or, on the contrary, you may pick a perfectly harmless scene— say a winter stroll out on the islands—bring in the sleigh carrying Pushkin and Danzas[23] towards their fateful encounter, exchanging courteous nods with passers-by as the first strains of a Requiem mingle with the jangle of sleigh-bells and peels of laughter, signalling

the poet's imminent demise, while he, oblivious, makes saucy re-
marks about various ladies—which of them are living with their
coachmen and so forth—and Danzas is trying desperately to draw
someone's attention to the case with the pistols, still hoping to avert
the fateful duel with d'Anthès...

Of course the next phase in the implacable march of disjunc-
tion—the disjunction of the object and its colour, indispensible none-
theless for any sort of creative, meaningful combination of action
and active colour-flow, flowing together into a dramatic whole—will
be the most challenging to established, conventional ideas.

For we, made all the wiser by past experience in other realms,
can already foresee and foretell that here—in the realm of colour—
fluctuations of the 'colour track' will assume the same function of
affective abstraction and acutely thematic expression of inner content
('subtext', if you will) as was assumed by the geometric schema of
the mise en scène of the Vautrin episode, or the parallel progress of
Myshkin and Rogozhin along the two opposite sides of the street, or
Makogon's action around the lock, or the gradual, magical unveiling
of Istomina in the passage from *Onegin*.

To rise to the level of music in its ability to express the inner
tremor of a scene, the colour track must learn once and for all to
dissociate itself from the naturalistic colouration of objects, must
learn to wrap the object and the event in the whirlwind of its colour-
ful embrace according to the inner logic of emotional expressiveness
rather than the dictates of 'how it is in real life'.

Translated by Sergey Levchin

Translator's Afterword

This expansive four-part essay is one of the very last texts composed by Sergei Eisenstein in the weeks before his untimely death at the age of 50 on 11 February 1948.

In the previous year Eisenstein had returned to a writing project abandoned more than a decade earlier: a three-volume course-cum-treatise under the general title *Directing* (perhaps better rendered by the amorphous 'Filmmaking' to reflect Eisenstein's conception of a director's role that extends far beyond the direction of actors).

At that time, in the early 1930s, following the demise of his 'Mexican picture' and his recall to the Soviet Union, Eisenstein received a teaching appointment at the fledging State Institute of Cinematography (known then as GIK, later VGIK). He immediately set out to devise a comprehensive three-year course of study for the aspiring filmmaker. According to Eisenstein's schema, as it evolved toward the middle of that decade, such a course would take the student through the successive stages of the director's craft: composing for the stage (*mise en scène*), composing for the 'vertical plane' of the film screen (*mise en cadre*), and composing in 'expressive movement' (*mise en jeu* and *mise en geste*—or what we might call, rather more blandly and not entirely to the point, 'directing the actor').

These were, moreover, the divisions of the three projected volumes of *Directing*. Boiled down from transcripts of Eisenstein's lessons at the GIK, the books would reproduce the 'director's practicum' approach that prevailed in his classroom, where much of the time was spent in painstaking, highly detailed analysis of staging decisions (whether of existing productions or classroom exercises), supplemented by occasional theoretical lectures.

The first volume, *The Art of Mise en Scène*—which follows Eisenstein and his students for some 700 pages as they doggedly debate every minute element of the mise en scène of a single, deliberately banal scene—had been assembled in somewhat rough form in the spring of 1934, when Eisenstein put aside his writing to begin preparations for *Bezhin Meadow*. After that film's disgrace, the filmmaker was forced from his teaching post and the *Directing* project was abandoned.

Nevertheless, in the ensuing years Eisenstein continued to make notes, sketches, journal entries, etc.—marked 'for mise en scène'—evidently intended for the unfinished first volume. At last, in the fall of 1946, following the success of *Ivan the Terrible*, Eisenstein returned to VGIK and renewed his interest in documenting his exceptionally meticulous creative process for posterity.

Soon after, three recent graduates of the Film Institute were given the chance to direct a collective debut from a screenplay by Katerina Vinogradskaya, also a VGIK alumna and former student of Eisenstein. This evidently served as the immediate impetus for the writing of the present essay, which draws its first example from Vinogradskaya's script. The essay, meant first of all to aid and encourage the three first-time directors as they prepared their film, is closely related to *The Art of Mise en Scène*—insomuch as each section features a step-by-step, highly detailed and thoroughly 'justified' derivation of some aspect of mise en scène.

Here, as in *The Art of Mise en Scène*, Eisenstein posits rigorous compositional unity, both of a scene and of the work as a whole, as the director's principal pursuit. To this end, all elements of composition must be placed in the service of communicating, or 'making sensible' some essential quality of the text as a whole, of a given scene, of a given moment...

This essential quality proves elusive. At various points in the essay it is said to be the interplay of character's motives, the essential quality of a character, the bond between two characters, the relationship between an individual and society, the essential quality of a piece of text, and—in the last section on the disjunctive use of colour—the filmmaker's unique perspective on the phenomena he has chosen to represent.

Whatever it may be, the essential quality (also referred to—somewhat reluctantly—as the 'subtext') of a given piece of text must be 'realised' or made sensible in every aspect of the mise en scène—i.e., the transposition of text onto the stage. The principal objective of the essay, however, is not to define 'subtext' or 'essential quality', but rather to differentiate several distinct components of mise en scène and to instruct the aspiring filmmaker in making full use of their evocative potential.

Thus, the first section concerns itself with *mise en geste*, the orchestration of actors' physical movements and gestures that lends compositional unity to the action: 'mise en scène on a personal scale'. To illustrate this technique Eisenstein selects a brief passage from Dostoevsky's *The Idiot* and proceeds to transpose it into a sequence of concrete actions, inventing along the way extremely minute and detailed movements and gestures and precise instructions for the eyes, hands, feet, etc.—all said to derive 'organically' from the 'essential principle' of inversion and negation, which Eisenstein attributes to Dostoyevsky generally, to Prince Myshkin particularly, and to this episode especially. The result is a remarkably structured (not to say over-structured), tightly controlled and entirely 'justified' piece of choreography, where nothing is left to chance and everything serves the 'essential principle'.

In the second section Eisenstein moves on to *mise en scène*,

understood here in a narrow sense as the physical disposition of characters in an acting space. This time the task is to 'make sensible' the relationship of an individual to society—the essential quality of an episode drawn from Balzac's *Le Père Goriot*—through the physical 'inscription' of mise en scène (i.e., the footprint of characters' positions and movements). Once again, Eisenstein demonstrates how a well-articulated idea of the underlying dynamics of a scene naturally dictates such practical decisions as where to place one's actors.

The third section of the essay was to be devoted to *mise en cadre*—understood by Eisenstein as both 'composition for the film frame' *and* 'arrangement of film frames', i.e., montage. The final paragraph of the essay refers back to a discussion of a passage from Pushkin's novel in verse *Eugene Onegin*; this section, however, was not found among Eisenstein's papers.

A brief discussion of this passage nevertheless does appear in another unpublished text, 'Notes on the Shooting Script of a Film about the Fergana Canal'. In early 1939 Eisenstein learned of plans to build a massive irrigation canal in the Fergana Valley of Uzbekistan. He envisioned a film that would document the construction and, simultaneously, tell the history of Central Asia, beginning with the invasion of Tamerlane's army and culminating in the heroic labour of the Soviets. The film, however, was shut down by the studio shortly after it went into production. In his post-mortem 'Notes', Eisenstein discusses a classroom exercise involving the staging of a passage from *Onegin*; believing that he had intended to use this passage in expanded form in the present essay, the editors interpolated it in place of the missing chapter.

The final section of the essay looks at colour cinematography as the newest viable element of evocative mise en scène. Before colour can become 'significant', however, it must become 'disjunctive'.

Recalling his 1928 'Statement on Sound', Eisenstein argues that colour can only become a full-fledged compositional technique in the service of 'the internal tremor of a scene' when it casts off the bonds of naturalism and embraces its full expressive potential as an independent 'colour-track' vis-à-vis the image.

Mise en jeu and Mise en geste appears here in English translation for the first time. It has been typeset in accordance with the style of the original manuscript. Eisenstein preferred to write in 'discrete shots', typically beginning a new sentence—and sometimes half-sentence—on a new paragraph.

The translator (and publisher) of the present edition would like to extend special thanks to the eminent Eisenstein scholar and keeper of his archives Naum Kleiman for his kind permission to translate the text. The translation has likewise benefitted enormously from Dr Kleiman's annotations and background notes on the Russian edition of the text.

Sergey Levchin
New York, 2014

Notes

1. A Soviet medical term, devised at the time of the Leningrad blockade to describe starvation disease—Trans.

2. Eisenstein draws his example from a screenplay written by a former student, Katerina Vinogradskaya; for its connection to the present essay see the Afterword—Trans.

3. This discussion is to be found in Eisenstein's unfinished book *The Art of Mise en Scène* [*Iskusstvo mizanstseny*]. In practical terms, a movement or a gesture may be preceded, for purposes of emphasis and contrast, by its opposite movement or gesture (e.g., oriented in the

opposite direction); this preceding element is described as the 'negating' movement. Evidently for Eisenstein this technique had broader philosophical implications—Trans.

4. In medieval Rus' the *terem* was the upper chambers of a dwelling, typically women's quarters. In Russian folklore maidens are invariably confined to lofty *terems* (presumably standalone towers in that context)—Trans.

5. Myshkin from *mysh'* (mouse); *lev* is lion—Trans.

6. Sergei Tolstoy, 'Turgenev v Yasnoi Polyane', in *Golos minuvshego* 1–4 (1919): 223.

7. The phrase in the original is 'Parfyon, nye veryu!'—Trans.

8. A.L. Volynsky, *Dostoevsky* (1906), 97. (Reprinted in 2007 by Akademicheskiy Proekt publishers in St Petersburg—Trans.)

9. Eisenstein and his students may be 'seen' working through this passage in the first chapter of Vladimir Nizhny, *Lessons with Eisenstein*, trans. and eds. Ivor Montagu and Jay Leyda (London: George Allen & Unwin, 1962), 3–18—Trans.

10. The Russian word for 'senseless' or 'absurd'—*nelepyi*—may be translated literally as 'unseemly' or 'unsound'—Trans.

11. Here belongs one of the lowest forms of comedy: the mockery (at the lowest stages of development) of physical deformity (i.e., negation of the vital standard, physically intelligible to all: recall the crowds mocking Quasimodo). We are naturally disturbed by this level of entertainment, by its cruelty. But we ignore the fact that we have not progressed much beyond it. Though we have largely overcome our ability to laugh at the cripple and the hunchback . . . the stutterer is still a common presence in our comic tales. Whereas a husband who lacks the physical ability to remain his wife's sole partner will invariably become the object of scorn.

12. I am deliberately avoiding any paradoxical or inverse solutions in favour of strictly 'canonical' composition, because at this stage

I am interested first and foremost in the question of 'codifying' the method of evocative mise en scène. Deviations from the canon very often result in brilliant and unexpected staging decisions, but before we can 'violate' canons we would do well to familiarise ourselves with the very nature of their canonicity. The limits we have imposed here fall within the basic standards of literacy for constructing evocative mise en scène.

13. See the second edition of his superb book *A World History of Art* (New York: Viking, 1944), 566–67.

14. Eisenstein refers to his unrealised film of 1939; this project, as well as the provenance of this section of the essay, is described briefly in the translator's Afterword—Trans.

15. It would be interesting to think about how one might film the 'beaming' of the theatre boxes, as opposed to any other sort of brilliance. We might recall here that verse of Selvinsky about waters that 'glimmer, glisten, glint'. A magnificent example of three finely differentiated script directions and three marvellous filming exercises for a young cinematographer—such that in the first the water glimmers, in the second glistens and in the third glints!

16. Curiously, for this shot nearly every one of my students—of those who had made any sort of effort to listen to Pushkin and follow his lead—drew not a violin bow but a conductor's baton. The 'magic' quality of the bow inevitably evoked the image of a 'magic wand', which was then transformed into the baton wielded by a conductor.

17. Kio was the stage name of the renowned Soviet circus performer and illusionist Emil Hirschfeld (1894–1965)—Trans.

18. This term describes the very essence of the 'magician's' skill: misdirection is what happens when he *substitutes* a flower bouquet for a guinea pig or an oleander for a larger oleander, so that the flower seems to 'grow' from seed right in front of our eyes.

19. One of the precursors to this was probably the grey uniform of

the Confederacy in the American civil war. The experiences of the Boer War must have also contributed to this development.

20. I cannot be sure now whether I had not in fact seen a similar—and similarly comic—trick in London in 1929, in the very first 'all-talking and all-colour' picture *On with the Show* (Warner).

21. Screenplays for colour pictures must be written in accordance with an entirely different dramatic method and follow an entirely different dramatic order than those of colourless pictures. But this must be addressed elsewhere.

22. This construction was entirely successful, according to all those who had seen the film. Many remarked that they did not even notice the switch between the colour and black-and-white scenes.

23. Konstantin Danzas, Pushkin's childhood friend and the second at his duel—Trans.

KINO-AGORA

Library and Archives Canada Cataloguing in Publication

Title: Mise en jeu and mise en geste / Sergei Eisenstein ; translated by
 Sergey Levchin.
Names: Eisenstein, Sergei, 1898-1948, author. | Levchin, Sergey, translator.
Description: Second edition. | Series statement: Kino-agora | Translated from
 Russian.
Identifiers: Canadiana (print) 20190226765 | Canadiana (ebook)
 20190226781 | ISBN 9781927852224 (softcover) | ISBN 9781927852231
 (PDF)
Subjects: LCSH: Motion pictures—Aesthetics. | LCSH: Motion pictures—
 Philosophy. | LCSH: Motion pictures—Production and direction.
Classification: LCC PN1995 .E3713 2022 | DDC 791.4301—dc23